DATE DUE

CHINESE LANDSCAPE PAINTING TECHNIQUES

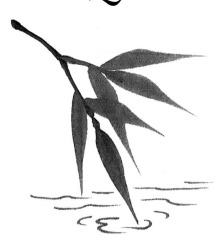

STEPHEN CASSETTARI

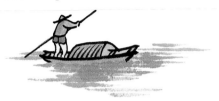

AN ANGUS & ROBERTSON BOOK

First published in Australia in 1990 by
Collins/Angus & Robertson Publishers Australia

Collins/Angus & Robertson Publishers Australia
Unit 4, Eden Park, 31 Waterloo Road, North Ryde
NSW 2113, Australia

William Collins Publishers Ltd
31 View Road, Glenfield, Auckland 10, New Zealand

Angus & Robertson (UK)
16 Golden Square, London W1R 4BN, United Kingdom

National Library of Australiia
Cataloguing-in-Publication data:

Cassettari, Stephen.
 Chinese landscape painting techniques.
 ISBN 0 207 16667 6.

 1. Landscape painting, Chinese - Technique.
 I. Title.

751.4251
Typeset in 11/12 Baskerville by Midland Typesetters
Printed in Singapore

5 4 3 2 1
95 94 93 92 91 90

CONTENTS

Dedicated to all those who
share in the study of this
ancient and living art.

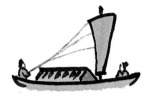

Thank you to Adrienne Brown
for all her help with the
manuscript and Donna Stacey
for all her design work.

CHAPTER 1

INTRODUCTION

Of all the various categories of Chinese painting, landscape is a most suitable one for those people who are interested in studying its practical side.

The fundamental techniques in Chinese landscape painting are the same for all the various categories of Chinese painting, but are more easily seen and learnt because of the repetition of brush strokes to form leaf patterns or rocks, etc., or because of the placement of the many varied elements in a composition, which produces plenty of practice to train the hand and eye. The skills learnt can then be easily adapted to the other categories. Even subjects such as rock, tree and water can be used to complement other subjects, as will be shown in Chapter 16.

Chinese landscape painting is also an absorbing and captivating subject in itself, like a wise old sage, full of depth and endless horizons, steeped in time and tradition. The forms and techniques were stylised during its peak of popularity in the Sung dynasty nearly 1000 years ago and have been maintained, with only minor variations and additions, to the present time.

Evolution and development and some famous painters
Background in portraits: Chin dynasty 265-419 A.D.
Landscape evolved: 5 dynasties 907-959—Li Cheng
Peaked as present form: Sung dynasty 960-1276—Mei Fei
Secondary peak: Yung dynasty 1277-1367
 —Li Tsan
Secondary peak: Ching dynasty 1644-1911
 —Shih Tao

Through all of the history of Chinese painting it has remained a popular subject, reflecting the harmonious relationship attained between the Chinese artist and nature.

Fig. 1 The most widely known form of presentation of a landscape painting is the vertical hanging scroll, with its overview of many horizons stretching back and up the scroll to give a panoramic idealised scene. Placed out only for occasions such as season, festival, birth, marriage, etc.

Hung from the top, it rolls up on to a bottom cylinder. The painting is the centre rectangle, with a brocade border. Quite a common length is two metres.

Fig. 2 There is also the horizontal hand scroll, meant to be viewed a section at a time (approximately 25 cm), while unrolling one end and rolling up the other and portraying a continuous story through time as well as space. (Further explained in Chapter 17.)

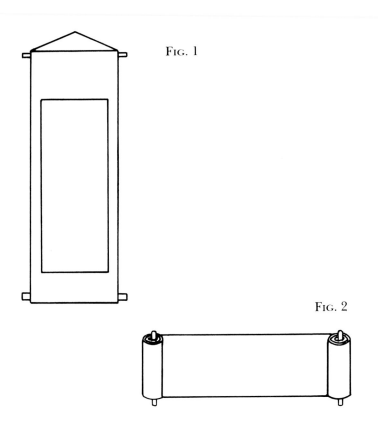

Fig. 1

Fig. 2

The third way, as mainly shown in this book, is the album page (a common size is 25 cm x 25 cm). Traditionally it is in book form with one page a painting and the facing page a poem in calligraphy, both complementing and enhancing each other. For illustrative as well as instructive purposes some calligraphy, both Chinese and Western, has been included in this book. (Chapter 18 presents an album page format.)

The album page is a most suitable format to practise as it has the simplest compositional style in size and content. Also, it is the most suitable to frame, for if the paintings are to be displayed for a length of time, they will need to be behind glass, as they are watercolours.

This book concentrates on the more traditional outline style, teaching the fundamental techniques, but also introduces the relatively more modern brush style, to give a rounded appreciation of the two styles.

The essence is permanent—The form is variable.

Having completed all the exercises in this book, you vill have attained the necessary ability to copy any Chinese landscape painting reproduced in books, calendars, cards etc., as long as the picture is big enough to distinguish the brush strokes used, or if possible to work direct from an original. This will develop your skills, enabling you to begin a composition from your own study of natural scenes. First, make a basic line drawing in pencil or ink to extract the essential features, then study each element in the scene to discover the brush strokes, inktone, etc. needed to express its character of hard, soft, strong, or flexible.

When adding colour, only reproduce those colours and tones that increase the visual effect you are trying to convey. Leave out all unnecessary subjects and colours or be willing to add, or rearrange visual elements in the pursuit of expressing harmony and balance, which is the main purpose of Chinese painting.

Begin a visual study of nature in conjunction with working from this book, as all studies of actual landscape elements, trees, rocks, water, etc., will help you in reproducing the traditional Chinese renditions of these elements, which themselves are extracted from the study of nature.

As the purpose is to take appropriate traditional elements and compose them in harmonious visual balance to depict the characteristic attitudes of seasons, moods, or sentiment, the

effects of light (shadows) are not depicted, having little connection with the timeless eternal qualities expressed.

Climbing a high mountain—Unfolds a long river.

An adaptation of an old Chinese saying that not only incorporates the essential elements in a landscape, those of a mountain which it is necessary to climb in order to view an expanse of water, but also, when applied to the study, indicates that a long and steep, though interesting and enjoyable, climb in technique and practice is required to achieve a vantage point to appreciate, as well as accomplish, the finished painting.

To complete the introduction, here is a simplified version of some aspects of Chinese painting, as expressed by Ching Hao, in the early tenth century.

Six Essentials:

Spirit	—	Mind follows movement.
Rhythm	—	Harmony.
Plan	—	Depict only the essentials.
Motif	—	In the sublime is the truth.
Brush	—	Unimpeded strokes.
Ink	—	High and low tones.

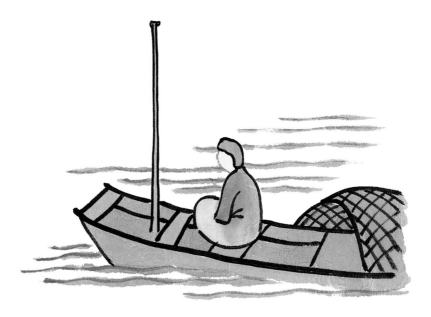

CHAPTER 2
EQUIPMENT

Fɪɢ. 1

A. GOAT HAIR BRUSH (White) with tape to strengthen join of hair and bamboo handle.

B. WOLF HAIR BRUSH (Red brown) with plastic reinforced join.

C. DEER HAIR BRUSH (Fine) with insert of smaller bamboo at join.

D. BRUSH REST made from a block of wood with holes drilled along the centre line, then cut lengthways.

E. ROLL OF RICE PAPER with simple tree example begun. The end of the roll is held down by two flat stones and the other end can be left attached to roll, as shown, or cut as required. (This is 'Moon Palace' paper made from cotton.)

F. INK-STICK

G. INK-STONE with round well, for grinding the ink-stick, and with the lid placed half underneath to tip the well, forming a reservoir (1) where wet, dark ink is kept. Dry ink can be obtained from the residue left on the slope (2). In the left bottom corner is a pouring hole to use for pouring excess ink into a container with a screw-top lid. This can be used later when working on a large painting where a lot of ink is required, so as not to interrupt the 'flow' of the painting by stopping to remix more ink. The ink in the well tends to evaporate quickly, hence the need for a reservoir. Place lid over well if not in immediate use.

H. SMALL WHITE DISH for mixing a small amount of black ink with water to obtain grey tones. The quality is easily determined on the white surface.

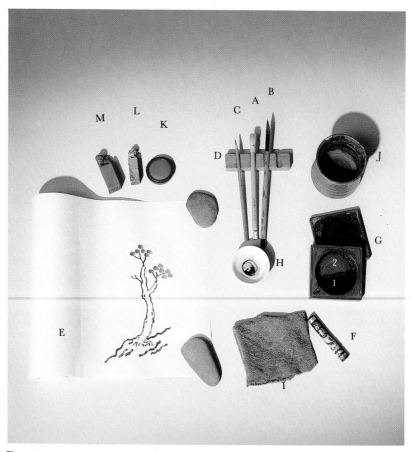

FIG. 1

I. FOLDED PIECE OF COTTON CLOTH for absorbing excess water from the brush to achieve dry ink effect.

J. WATER CONTAINER This one is of a very suitable design with a wide opening giving easy access to water. It is not too high and has a firm, wide base of heavy clay to make it more stable.

K. SEAL STAMP PAD of vermillion oil-based ink. It has a screw-top lid (not shown).

L. M SEALS Made from soapstone, as are all the seals used in this book. Both have my painting name, Nay-Lee, which can just be seen, carved on the base in relief characters (L) as used in Chapters 5, 11, and 12 and in indented characters (M) as used in Chapter 13.

This photograph shows a suitable placement of equipment (for right-handed painters) when working. The tallest equipment is at the back, allowing hand and brush to move, from water to ink, to 'grey' dish, to paper and back to brush rest, in an easy, flowing, circular motion. Seal and ink are nearby but not in the way. Stones are flat also for this reason.

The specialised equipment of the 'Four Treasures' is common for all categories of Chinese painting, as well as Chinese calligraphy. Their proper handling and care are essential for good results.

The following information is reproduced (slightly altered) from *Chinese Brush Painting Techniques (Birds and Flowers)*. More particular advice for landscape purposes follows.

BRUSHES

The brush is usually made from animal hair set into a hollow bamboo handle. The better-quality brushes have some sort of binding, or sometimes a piece of copper, where the handle joins the hair, to hold both together and prevent the bamboo from splitting. A piece of tape can be applied for the same purpose. There is usually a loop on the end of the handle so that the brush can be hung up to dry. Brushes are not numbered by size as other painting brushes are, but a wide variety of brushes designed for different uses is available.

Care of Brushes After buying your brushes, discard the bamboo covers and soften the hairs in cold water. Always wash brushes in cold water and occasionally soap, never in hot water, and shape the brush tip to a point to dry. Carry your brushes in a rolled mat to protect the hairs.

The main brush needed will be a good quality, Fɪɢ. 1 ɪt red-haired brush. This is useful where control of the stroke is important, as in brush-style leaves or the graceful water strokes. Also useful is an old red-haired brush that has been worn down at the tip, to give a blunter end. (Or the tip of a new brush can be cut, but the effect produced is not so natural until the hairs have worn down a little.) This brush is ideal for producing the rough-looking strokes for tree trunks or rocks and also for the round foliage dot.

A number of soft, white-haired brushes are useful for applying the colour washes, and painting the broad strokes needed for distant mountains and brush-style tree trunks and rocks. At least four will be needed to avoid washing out the hairs for each

colour change. These can be of various thicknesses for different sized areas to be coloured.

A very fine version of the red-haired brush is suitable to easily obtain the taut, wire-like strokes used for leaves in outline style or for constructing houses, bridges, etc. This would be the thinnest type of Chinese brush that is available. The other brushes need their distinctive shape to produce the various thicknesses of line in the brush strokes and therefore cannot be interchanged with Western watercolour brushes. (Also because of their size Western brushes would be relatively too heavy and cumbersome for the delicate, single stroke effects.) The fine brush can, however, be substituted by an O or OO brush, as it is the even control of line that is required.

A brush rest allows the brushes to be laid level and keep the work area clear. Do not stand them in the water container. A chopstick rest or a piece of driftwood with notches are other ways to make a simple brush rest.

PAPER

Newsprint, the paper newspapers are printed on, is the best paper to begin with. It can be bought in the form of scrapbooks, or ends of rolls or blocks can be bought direct from a printer. Cartridge paper and most art papers are not suitable, as they are not absorbent enough.

After a little practice, it is advisable to begin using rice paper. This comes in rolls and sheets and is made from a variety of natural materials such as cotton, rice plant and mulberry. A very white paper made from cotton fibres is best for all-purpose work. Use the smooth side for most subjects—flowers, birds, people and so on—and the rough side for landscapes. Most rice paper is highly absorbent. Experiment with different types to discover which you like best for various effects.

Always carry rice paper rolled or flat in sheets. Never fold or crinkle it, as this makes the surface difficult to paint on. A cardboard tube is useful for carrying paper.

To tear rice paper, simply run a wet brush across the surface, making an even, thin line of water, and pull the paper apart slowly.

Once you have gained some practice on newsprint, the sooner you start using rice paper the better. You will get better results, and you will also learn the importance of working quickly. When using rice paper, first place a piece of newsprint or felt

underneath to absorb any excess water that soaks through the paper.

A small amount of outline work can be practised on blank newsprint paper, but as much of landscape painting requires areas of soft washes, the more absorbent qualities of rice paper become essential for any degree of excellence in the finished work. The thicker, stronger types of paper are more suitable for landscape painting as they will not break up when saturated during the colour wash and will take some over-working, wet paint on wet washes, or dry on wet.

If the rice paper has a different texture on each side use the rougher side for landscapes to help create the dry strokes for tree trunks and rocks.

All the paintings in this book are worked on 'Moon Palace' paper, a variety from Japan. The front cover was painted on rice paper called 'Floating Dragon' in reference to the fibres clearly seen in the body of the paper.

The deep browns of Mulberry paper are also effective for the 'ancient look'. This look can also be obtained by soaking a piece of blank rice paper in a diluted mixture of water and indigo and burnt sienna watercolour or a strong tea brew. Practise with small pieces first as the rice paper is very fragile when wet. Dry the rice paper by laying it flat on a tea towel and leaving overnight.

INK-STICK
To begin with, a tube of black watercolour of student quality is good enough. It is better not to use acrylic or poster paint, and Indian or similar ink should definitely not be used, as these can destroy the hairs of the brush. Later you will need an ink-stick, which is made of solidified soot (usually pine) and fish glue. Don't buy the similar ink that is available in bottles, as this is designed for calligraphy and does not dilute well to produce the varying tones.

Ink-stone You will also need an ink-stone to grind the ink. A simple ink-stone, either round with a lid or oblong with a shallow end, is best. The heavier, more expensive ones are made of natural stone.

To grind the ink, first place a cloth underneath the stone to prevent it from sliding. Wet the surface with just a couple of drops of water, hold the ink-stick upright (as you would a brush) and grind it gently on the stone in a continuous motion,

either up and down or round and round, as shown below, until the ink is very dark (at least 5 to 10 minutes), adding more water as needed. The ink can be picked up with a brush directly from the stone or placed on a palette and mixed with water to achieve various tones of grey. Ink can be left for an hour or so if it is covered.

Don't leave the ink-stick standing on the stone, and don't hold the stick too tightly, as this could break the stick. Wash the ink-stone clean after each use.

As soon as you are producing finished work on rice paper it will be necessary to use a good quality ink-stick, made with pine or wu-tung soot. Not so suitable are the smaller, cheaper ones, which are made with lampblack. The ink-stick is more economical than other forms of black paint, because of the large amount of black used in Chinese painting. Also, of most importance the ink will not lose its tonal strength by being soaked into absorbent rice paper or when it is covered with translucent washes. Information on colours, their types and uses and their palettes is given in Chapter 10, when they will first be used.

An ink-stone is a necessary surface for grinding the hard glue used in the ink-stick.

Dilute black with water to obtain grey tones. Do not use white as this will flatten the tone and produce an opaque quality.

A large water container is best for washing off the black ink from the brush. Allow the water in this to become quite dirty as the glue from the ink-stick that has been transferred to the water will help fix the other colours.

A small container of clean water can be kept nearby for when a particular bright tone of colour is desired, for example, in clothing.

With a firm understanding of the equipment, you are ready to put it to use.

CHAPTER 3

BASIC BRUSH
STROKES

基
本
筆
法

The basis of Chinese painting originates through the equipment
and the techniques evolved from the writing (calligraphy), which
itself has evolved from small pictograms.

There are a number of basic strokes, with variants, which
form the Chinese calligraphy characters. These are used, with
more variations in stroke, as well as angle of brush and tonal
value, to produce all the outlining techniques in Chinese
landscape painting.

For all the brush strokes in this chapter, the brush is held
in an upright position, perpendicular to the paper. The fingers
hold the brush handle comfortably, the longer the stroke the
higher the fingers are held up the handle of the brush. The
fingers and wrist are kept firm and still, the movement which
produces the stroke coming from the elbow and/or shoulder.
Very small work can be produced with finger movements. For
very fine lines move the little finger, or the wrist, along the
paper as a steadying guide.

This full arm movement also applies to all the brush
techniques in later exercises, even when the brush is held in
different positions or at different angles. At first, this way of
manipulating the brush may seem a little awkward, but with
time and practice it will feel most natural and will help produce
the firm, but flowing, motions needed to obtain the strokes and
their underlying rhythm.

All Chinese painting is produced on a level surface,
traditionally standing at a bench top. This is most practical
for large work, but a table and chair is more suitable, as long
as the arm can move freely above the working surface. The
body can be raised by sitting on a firm cushion.

To produce the following practice strokes, use both types of brushes to see the abilities of each. For pointed, finished strokes, the red-haired brush will give the best results. For rounded, finished strokes, the white-haired brush is best.

Load the brush with dark ink, or black watercolour, mixed with enough water to move it easily across the paper, but not too diluted to produce a grey tone. If the ink is too wet, it will 'bleed' over the edge of the stroke. If too dry, it will leave areas of white paper. Both of these effects can be of use in later exercises, but at the start learn to control the ink to obtain a rich, dark black.

All the strokes are painted with a single movement of the brush, with no corrections. If you are not content with the results of a stroke, just paint another one.

All the strokes are painted left to right, top to bottom. This is a rule for calligraphy but is not so strict for landscape painting.

Remember to keep the brush upright and use a whole arm movement for each stroke.

BONE STROKE: For tree trunks, branches, rocks, houses, etc.

FIG. 1 Place the tip of the brush on the paper, pressing down slightly, then raising the brush halfway up and move across the paper, pausing, before pressing the brush down again, raising the brush halfway up and moving back over the stroke as the brush is lifted off the paper to produce a stroke that has a bone shape. This is also 'one', the number as well as the adjective.

FIG. 1

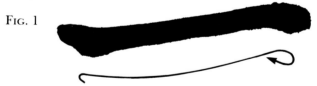

FIG. 2 A thinner bone stroke, using less pressure throughout. An exercise to control the tip of the brush.

FIG. 2

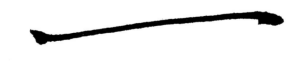

NEEDLE STROKE: For leaves, especially pine and bamboo.

FIG. 3 Begin this stroke with the brush on the paper, pressing down slightly and raising the brush a small amount, before moving it along the paper, slowing lifting the brush to its tip as you move the brush steadily and continuously off the paper.

This stroke starts the same as the bone stroke but finishes the same as the orchid leaf stroke, Fig. 4. To achieve the point on the end of the stroke, follow through as the brush moves off the paper so that it continues through the air for about the width of a hand.

Paint this stroke in different directions for extended practice. Reload and repoint the brush, by stroking the hairs on the palette, for each stroke.

FIG. 3

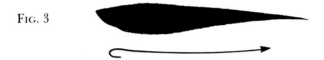

ORCHID LEAF STROKE: (Not used in calligraphy but important in landscape painting.) Expresses the gentle, insubstantial quality of water.

FIG. 4 Begin with the brush off the paper. Move the tip of the brush on to the paper, steadily increasing pressure, while continuing to move along, applying the most pressure in the centre of the stroke and raising the brush back up to its tip and off the paper as in the needle stroke. Make sure the brush is well-pointed for this stroke. There is a continuous steady movement unlike the stop, start, stop of the bone stroke.

FIG. 4

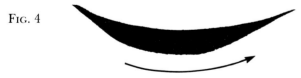

TEARDROP STROKE: For many types of leaves.

FIG. 5 Just as the bone stroke and the orchid leaf stroke are complementary opposites, so the needle stroke has a balanced opposite in this stroke.

13

Start off the paper, moving the brush slowly down and along, to contact the paper with the tip of the brush which is kept moving to produce a narrow beginning to the stroke. Lay more of the brush down on to the paper, finishing by rolling the brush around and back over the stroke as it is lifted up and off the paper, to create a rounded end. This stroke begins like the orchid leaf stroke and ends like the bone stroke.

Fig. 5

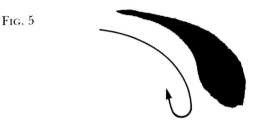

SPOT STROKE: For leaves, foliage dots.

Fig. 6 For this stroke, simply lay the point of the brush down on to the paper increasing the pressure, then raise the brush back up and off the paper with no horizontal movement used.

Fig. 6

HOOK STROKES: Vigorous strokes for rocks and tree trunks.

Fig. 7a A bone stroke, but as the brush is rolled around at the end of the stroke, instead of returning the brush back over the stroke, bring the tip of the brush out of the side of the end of the stroke as it is lifted off the paper.

Fig. 7a

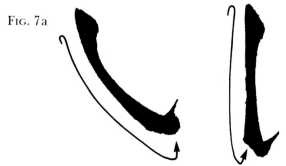

Fig. 7b Note the knuckles, or joints, that occur when a stroke changes direction. These are made by applying a little more pressure at these points to strengthen the 'bone' of the stroke.

It has already been observed that there is an interconnection between the strokes. As in the natural form from which these strokes have been extracted, the circle (spot) is the fundamental shape.

Fig. 7b

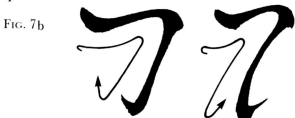

Fig. 8 Begin with a spot. If a slight horizontal movement is introduced as the brush is lifted, a small tip will appear. If the length of this horizontal movement is increased, the length of the tip will be increased until a needle stroke is produced. If, just as the tip of the brush is about to lift off the paper, the brush is returned down on to the paper and rolled back over the stroke, a bone stroke will be produced. If the bone stroke is finished with a pointed spot stroke, then a hook stroke will appear.

All the strokes have a start, middle and finish, either concealed or exposed. For example, Bone: both ends are concealed. Orchid leaf: both ends are exposed. Spot: middle is concealed.

Fig. 8

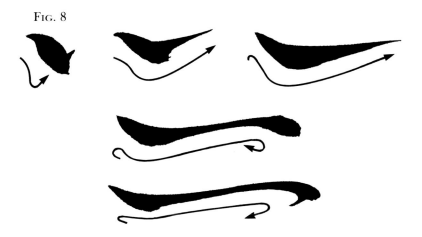

SWIMMING FISH: Not used much in painting, but an important stroke in calligraphy, especially as a finishing-off stroke.

FIG. 9 Paint a bone stroke on a downward sloping angle, left to right. At the finish of the stroke, instead of returning the brush back over the stroke, continue to slide the tip of the brush out of the end of the stroke and off the paper, to produce a characteristic angle with a flat base line. Concentrate on producing the top of the line and the flat base will take care of itself.

FIG. 9

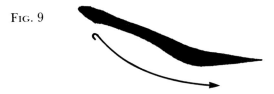

TWO IMPORTANT CHARACTERS:

FIG. 10 'Eight.'
FIG. 11 'Person' or 'people'.

FIG. 10 FIG. 11

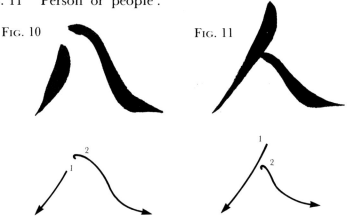

There is a slight variation at the beginning of each of these strokes.

The above are the seven main strokes.

There is considered to be an eighth 'stroke' that is the path of the brush as it moves between the strokes. Though it leaves no visible mark on the paper, it nevertheless is made by the

artist and is essential in obtaining the rhythmic flow of each brush stroke, reflected in the whole character or painting.

Load the brush well with dark, wet ink and paint each character or pattern in the numbered order, without pausing to reload or reshape the brush. The dotted line is the movement of the brush after it has been lifted off the paper.

FIG. 12 This is often used when the character for 'water' is combined with another character to form a different character.

FIG. 13 Cursive style of writing 'mountain'.

FIG. 14 Cursive style for 'sun' or 'day'.

FIG. 15 Chinese character for 'small'.

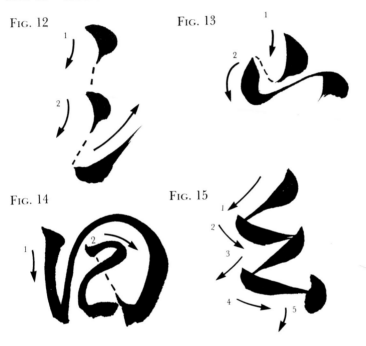

FIG. 12 FIG. 13

FIG. 14 FIG. 15

A character 'eternity', illustrating the eighth movement of the brush.

FIG. 16 In regular script. Do strokes 4 and 5 as one movement.

FIG. 17 Cursive (grass) script.

In regard to the Six Essentials in the Introduction, Chin-Hao further explains brush strokes as: Short-muscle; Undulating-flesh; Firm-bones; Undefeatable-spirit. Thus the importance of using brush strokes to create a living work of art.

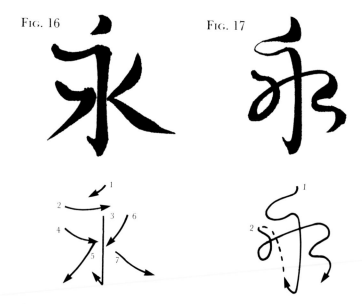

Fig. 16 Fig. 17

TONE

Having accomplished a dark, wet tone of ink, try to obtain a middle grey tone by placing a small amount of black onto a small white saucer and add about an equal amount of water, mixing the two well together. The white surface of the saucer will help you gauge the correct amount of water needed.

Fig. 18 Use this light tone to paint an orchid leaf stroke, as in Fig. 4.

Fig. 18

CONSISTENCY

Dry ink is obtained by first washing the brush in the water, then, after taking the excess water out on the side of the container, dab the still wet brush on a piece of absorbent cotton cloth. This will take out more of the water, especially around the base of the hairs where they meet the bamboo handle. Pick

up black on the brush from the slope of the dish, or from the ink-stone where the black has dried out a bit. Dab the brush again on the cotton cloth if necessary.

FIG. 19 With the brush at an angle of 45°, paint a bone stroke, top to bottom. Tone and stroke are suitable to express the hard, rugged appearance of rocks. Paint fast and without much pressure, so that the rice paper does not have time to absorb too much ink. This will produce the 'flying white' effect.

FIG. 19

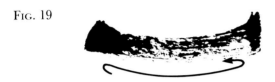

With both light and dark ink experimentation with the amount of water and the speed of movement is necessary, with time, for good results.

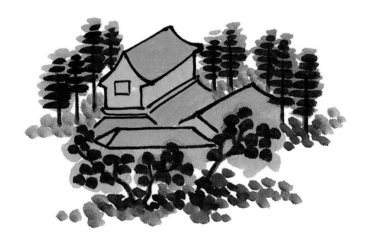

COMPOSITION—ORDER, PROPORTION AND PERSPECTIVE

ORDER OF PAINTING

Information in this chapter can be referred back to, as a particular aspect arises in the course of completing the later exercise chapters.

Chinese landscape begins with the painting of the foreground and progresses towards the background. In the traditional 'Bone' method of painting, outlines of various qualities, and tones of black (wet, dry, hard, soft) are used to create the structure of the painting. This is reinforced with a soft grey wash to define certain areas (planes of rocks, sections of water, leaf masses). Then a colour wash is added, the 'flesh' over the 'bone', to create a living painting.

The quality of colour can vary from completely monotone black and grey, through soft colour washes of natural tones, to quite dramatic use of bright mineral colours, especially blue and green, according to the mood of either the artist or the requirements of the painting.

The detailed list that follows is a guide to help in the construction of a traditional Chinese landscape or a study from nature that you may wish to depict in the Chinese method. This list will help guide the way through what, at first, seems a complex composition. Where to begin? What to do next? It shows the simple, underlying motifs and themes common in all Chinese landscape paintings.

Each step is briefly described, so that the list can be used as a quick reference while painting.

Variations of this order may be required for certain compositions, so be flexible in its application.

Each exercise chapter will explain each step in the full details required for painting.

Steps 1-4 are all in tones of black ink.

1 Foreground

In 'looking down' perspective there is no foreground.

A Trees-trunks (From top downwards)-branches-leaves.

B Rocks (Outline each rock, then place in the 'moulding' strokes, before starting the next rock).

C Houses/People (Includes all human dwellings and constructions. Paint from top downwards).

2 Middle Distance

A Rocks (The distance these are placed from the foreground will create the depth in the painting).

B Trees-trunks-leaves (No branches, trees show less individual characteristics at a distance).

C Houses/Boats (These contain less detail than those in the foreground).

3 Background

A Mountains (Mountains must remain separated from each other, as well as from the middle distance. They have no base line, so as to produce the effect of 'floating above the mist').

B Trees (Use dots for trees. Apply when mountains are still slightly damp for faded effect).

4 Water

Use the empty spaces to express distance. The less water strokes, the less movement is evoked in the water.

5 Colour Wash

Apply in the same order as when painting the outlines. Add lighter tones to rocks before the darker tones, slightly overlapping the lighter tones. A second wash can be applied after the first is dry to add more 'body', especially in the trees and rocks. Keep the wash very pale and not all over the water area.

6 Foliage Dots

In black or green, when the colour wash is almost dry.

7 Calligraphy and Seal

Place in the appropriate space. Use the red of the seal to balance any strong area of colour in the painting.

Host-Guest-Servant Relationship

A Chinese landscape painting will usually consist of these three relationships for the positioning of the elements within a composition.

They can be most easily seen in a simple composition but they are also the underlying compositional basis for even very involved compositions.

Three structural relationships:
Host–Active–Foreground–Water space–Trunk–House
Guest–Passive–Middle distance–Sky space–Leaves–Tree
Servant–Supportive–Background–Mist space–Branches–Rock

There will also be Host, Guest(s) and Servant(s) within a group of trees (See Figs. 12, 13, 14 Chapter 5), or rocks, (See Figs. 12, 13, 14 Chapter 7).

The host is painted first, awaiting the guest. The host is the largest, most prominent, most ornate and detailed. It has the most character, although does not dominate the composition, but rather leaves room for the arrival and presentation of the guest, which is painted second, in a position or attitude to complement the host, often by being its balanced opposite. A second tree in a different direction, slightly smaller than the host, plays the important function of creating harmonious accord. The servant is painted third and is used to support the host-guest grouping by being similar in attitude to the host but smaller. It is placed in a supportive position by adding its 'visual weight', thus making the group complete in balance. For example, it can serve the purpose of keeping the host-guest group from toppling over, as in Fig. 14 Chapter 7.

PROPORTION

This is different from the way of Western painting, seen through the eye or camera, in that it is rather *felt*, as a heart-view that looks beyond the particular view to the comprehensive overview.

The proportion of each subject can be used as a means of expressing its character, as important as the line or colour used. For example, the leaves of a tree are usually depicted individually much larger in proportion to the trunk, to express the variety of texture and form inherent in each type of leaf pattern, but the overall impression is still conveyed of a full mass of leaves, thus making two visual statements, that of the particular and that of the whole. Houses or people are shown in clear lines even when far away, to convey the importance of their presence on the landscape, but they are usually painted small in the

overall composition to express their harmonious relationship with nature, rather than dominating the scene.

PERSPECTIVE

The distinctive types and their use are dealt with in practical examples in Chapter 13. It is quite acceptable, as in early European art (pre-Renaissance) to have more than one perspective in a single painting. As with proportion, perspective is used as an artistic means of enhancing a visual statement, conveying more than a single, fixed view. It is permissible to see the view behind hills that should block the line of sight, or see inside the house (just a glimpse to stir the imagination), as well as the roof and outside walls. The viewer is not treated just as a passive observer but instead is required to be an active participant in the painting.

When studying completed examples of Chinese landscape paintings, notice that there is usually a visual path of empty paper that leads the viewer from the foreground, up through the composition, to the sky.

This recalls an old Chinese legend of a landscape artist who, when he had finished his large mural, felt completely overwhelmed and absorbed in his own creation and put down his brush, climbed into the landscape, boarded the boat and sailed away to the horizon.

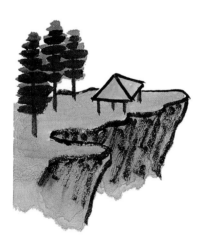

C H A P T E R 5

TREES—TRUNKS
AND BRANCHES

The following chapters are in the order of composing a completed painting.

Most of the examples shown throughout this book have been reduced in size. For easy practice, paint each example between 2 to 4 times larger than shown, or whatever scale feels most comfortable to work with.

Remember, the purpose of copying is not to make an exact reproduction but to learn the fundamental techniques. If you make some difference in the early stages of a copy, be willing to make changes where needed in the rest of the example to keep a harmonious composition. Usually this will mean simplifying, by leaving some parts out.

A good method of working is to look at the illustration, then read the instructions, then carry them out, with the example in front of you. Refer back to the instructions as needed.

Note for left-handed painters: When constructing trees, rocks, houses, etc., it is best to paint the right side before the left side. This way, the hand does not cover the lines already painted. You will need to see these lines for judging the placement of the rest of the lines, thus reproducing the correct proportions of the subject.

The foreground tree or tree group forms the main focal point of the Chinese landscape painting, comprising of as much detail and attention as the flower in a flower painting.

Begin by painting the trunk. Use an old, red-haired brush, loaded with slightly dry ink of almost the darkest tone, saving very vivid, dry black to express the harder, stronger rocks. Hold the brush at an angle, slightly lower than upright to make a

thicker stroke. This slight angle will spread the hairs of the brush while painting to aid in producing the 'dry' effect.

FIG. 1 Start at the top of the trunk. Paint a bone stroke, as explained in Chapter 3, using a downward movement, pulling the brush quickly across the paper, without too much pressure.

FIG. 2 After completing the first bone stroke and without lifting the brush from the end of the stroke, begin a second bone stroke, continuing in a series of connected bone strokes down the left-hand side of the trunk, including the roots.

FIG. 1 FIG. 2

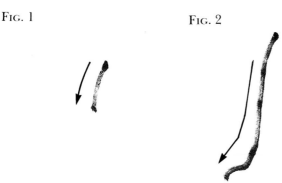

FIG. 3 Then paint the right side of the trunk. The first line will be visible as a guide in achieving a natural thickening of the trunk the closer it is to the ground.

FIG. 4 Leave a gap in the outline to add the fork in the trunk.

FIG. 3 FIG. 4

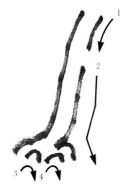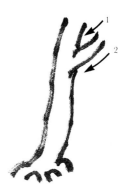

FIG. 5 Fill in the texture strokes of the trunk, all with strong, short bone strokes. If the brush runs out of ink while painting the trunk, it is quite acceptable to reload the brush, but be careful to keep the same tone and consistency of ink.

FIG. 5

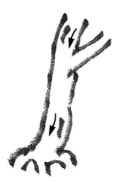

FIG. 6 Add the branches using the same brush, but held upright and with wet, dark ink rather than dry ink, to obtain the flexible quality of the branches. Paint each branch in a single bone stroke.

FIG. 7 Add the branches to the trunk, top to bottom, left to right. This will allow you to place the correct height of the tree on the paper, which is of great importance in the overall balance of a composition.

FIG. 6

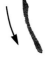

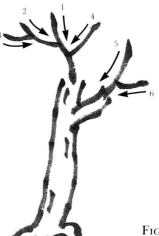

FIG. 7

26

Here are some branch patterns attached to trees, for practising various attitudes and postures of trunks.

Fig. 8 Standing upright.
Fig. 9 Leaning forward.
Fig. 10 Stretching out.
Fig. 11 Stooped over.

Fig. 8

Fig. 9

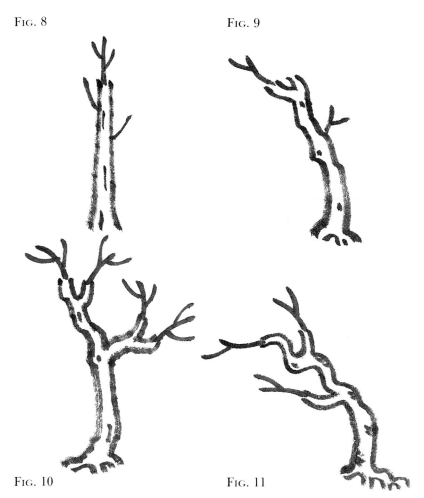

Fig. 10

Fig. 11

When completing a group of trees, allow each tree to aid in the balancing of the group. Be aware of the white spaces that are made by the intersecting and adjacent trunks and branches.

27

A—Host B—Guest C—Servant
FIG. 12 An 'X' pattern.
FIG. 13 A 'Y' pattern.
FIG. 14 A variation of Fig. 12.

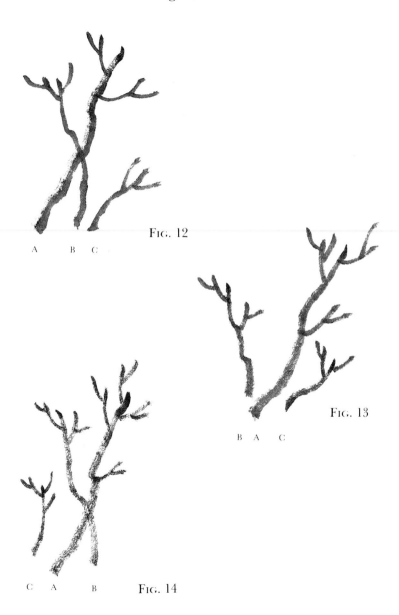

FIG. 12

A B C

FIG. 13

B A C

C A B FIG. 14

TREES—LEAVES

樹葉

The traditional technique of painting leaves is to use strokes to portray individual leaves, forming an overall leaf pattern with the realisation that not all the leaves on a tree can be depicted. Through brush stroke, leaf pattern and colour, and silhouette, the individual character of each tree can be expressed.

The trunk is the host and the leaves are the guests, helping to illuminate the trunk by being placed on both sides but not over it. They can be painted over the branches. All the leaves on the one tree consist of the same stroke, of the same size and same direction.

For painting leaves with a round finish, use a white-haired brush. For painting leaves with a pointed finish, use a new red-haired brush. The arrowed line gives the direction and movement of the brush for that particular leaf, with the arrowhead at the end of the stroke. For the creation of the individual brush strokes described, refer to Chapter 3.

If it is mentioned that, for a particular stroke, the brush is to be held at an angle, then this should be at 45°, unless otherwise specified.

DOT LEAF

This is a basic leaf pattern to express the visual symbol 'tree', with characteristics inherent in all trees. More specific tree types follow this one, but the same principles of construction apply to all leaf patterns.

Load the brush with water, then pick up dark, wet ink, holding the brush at an angle.

Fɪɢ. 1 Paint a dot stroke, with the movement illustrated.
Fɪɢ. 2 Make a pattern of dots in the order shown.
Fɪɢ. 3 Add as many dots as are needed to form the leaf group, continuing to build repetitions of the basic starting pattern of five. This pattern will need odd dot strokes added to form a more natural appearance for a leaf group.

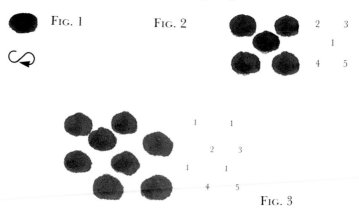

Fɪɢ. 1 Fɪɢ. 2

Fɪɢ. 3

All the dots are approximately the same size. Make them smaller and placed closer together when placing them around branches and trunk to form a tree. They do not have to be actually fixed on to a branch, there being many smaller branches not shown.

Fɪɢ. 4 Not like this silhouette of a leaf pattern and tree. It is too geometric with the trunk and branches too even and stiff.

Fɪɢ. 4

INCORRECT

FIG. 5 This design has a more natural appearance. Nature tends to meander along her way to beauty.

FIG. 5

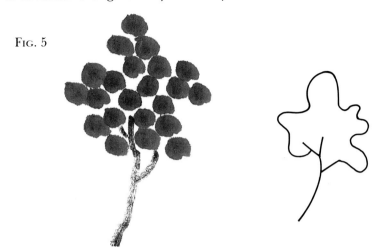

OTHER DOT PATTERNS
FIG. 6 Hold the brush at an angle, tip of the brush pointed away from the body. A short vertical teardrop stroke.
FIG. 7 Pepper dot. Use a slightly angled brush, pressing only the tip down, to form a small, lively spot.

FIG. 6 FIG. 7

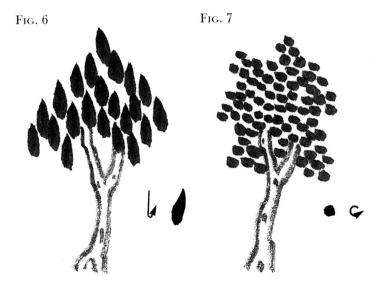

31

Fig. 8 For this outline technique, use an upright, fine brush and form a hollow circle with a bone stroke. Make the circles touch each other to form a net-like pattern closer together than the brush style dots. This pattern is very suitable for a colour wash—light green for summer, red (vermillion) orange for autumn.

Fig. 8

WU-TUNG LEAF

Fig. 9 Paint a leaf stroke as in Fig. 6.
Fig. 10 With the first stroke as the centre of the leaf, add the other strokes diminished in size and angled away from the centre stroke, to form one large soft leaf with four lobes.

Fig. 9 Fig. 10

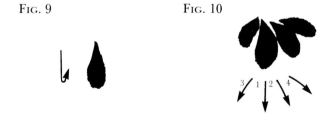

Fig. 11 Brush style leaves on a tree. Still follow the pattern of five to construct the overall leaf pattern with an uneven, natural silhouette. The trunk of the Wu-Tung is fairly straight.
Fig. 12 Outline style. Each leaf is made from two curved bone strokes.

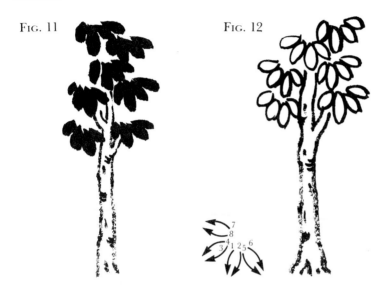

Fig. 11

Fig. 12

PINE TREE LEAF

Portrays the hard vigour of winter.

Use an upright brush with dark, wet ink.
Fig. 13 Paint a needle stroke with a downward movement.
Fig. 14 Add a number of needle strokes to form a leaf group. Strokes are painted from the outside of the leaf group to the centre, all meeting, or appearing to meet, at only one centre. The exact number of strokes is not too important, as long as the sides of the leaf group fan out to just over half a circle, as shown in the diagram.

Fig. 13 Fig. 14

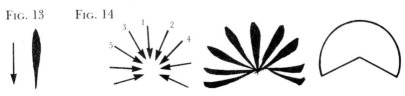

FIG. 15 Line drawing of leaf groups, in a half-circle pattern, arranged on trunk and branches.

FIG. 15

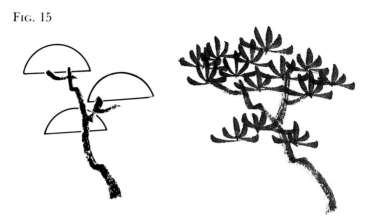

FIG. 16 A finished leaf pattern on a trunk. Individual leaf groups overlap to thicken the appearance of the pattern.

FIG. 16

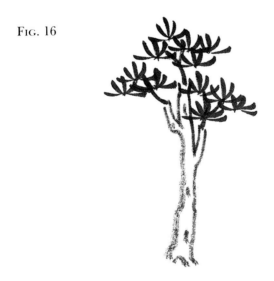

The pine tree, symbolising long life, is the most represented tree in landscape painting. Its equivalent in flower painting is bamboo.

Other Pine Needle Groups
FIG. 17 Black pine. Complete a circle of leaves around one point. Scalloped-shaped scales in the trunk are typical texture strokes for the pine tree.

FIG. 17

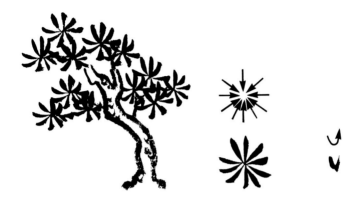

FIG. 18 Cone-shaped leaf group.

FIG. 18

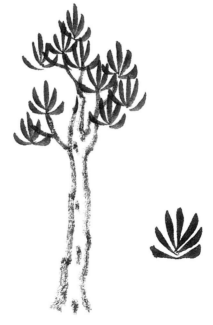

FIG. 19 The needle strokes are attached directly to the branches for a more vertical appearance.

FIG. 19

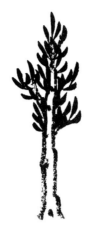

BAMBOO

FIG. 20 Use the same stroke as for the pine needle.

FIG. 21 The overall group consists of five strokes. If only four are occasionally painted this is acceptable. The leaves radiate out from the top. There is not one starting point for all the leaves—rather the top is more open to give the natural formation of a bamboo leaf group, as the leaves do not all grow out of the same position on a stem.

FIG. 22 Not like this. The top of the leaf group is too congested for bamboo. This looks more like a maple leaf.

FIG. 20 FIG. 21

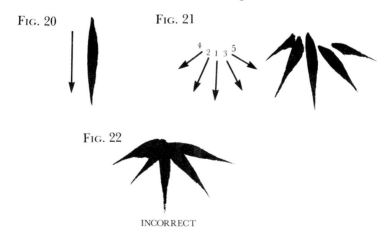

FIG. 22

INCORRECT

FIG. 23 Paint the bamboo stem in single, separated bone strokes. Use an upright red-haired brush loaded with wet, dark ink. The stems are painted top to bottom. Centre–host–stem, then the left–guest–stem, then the right–servant–stem. Then add the branches.

FIGS. 24a,b,c Show how to construct a complex leaf pattern. Place a few leaf groups throughout the intended area to be covered, to form a guide. Add a few more leaf groups to slowly complete the full pattern as one visual unit, still retaining the structural pattern of fives.

This concept can also be applied for the Wu-Tung and pine trees.

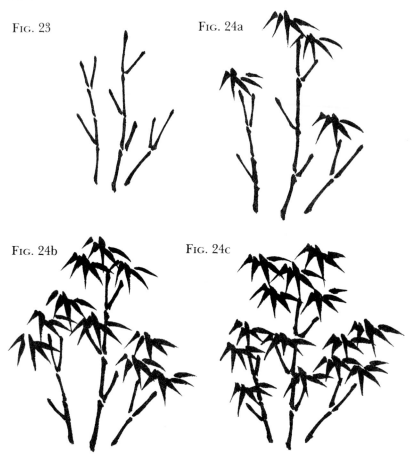

FIG. 23

FIG. 24a

FIG. 24b

FIG. 24c

FIG. 25　Young bamboo, with leaves pointing upwards.

FIG. 25

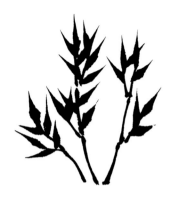

WILLOW TREE

Expresses the soft, graceful aspects of summer.

FIG. 26a or b　Two variations of the willow leaf. Use a long, gentle needle stroke in a medium tone of grey, with an upright red-haired brush. Paint the strokes in a single direction.
FIG. 27　This is not correct as the stroke curves again at its tip.

FIG. 26a　　　　　FIG. 26b　　　　　FIG. 27

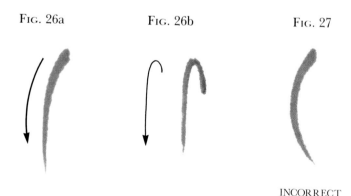

INCORRECT

FIGS. 28a,b Construction of the leaf pattern. Each leaf should be attached to a branch or another leaf. Some of the leaves cross over each other, forming a pleasing pattern of white spaces.

This stroke, and the pattern shown in Fig. 28a, can also be used for waterfall effects.

FIG. 28a FIG. 28b

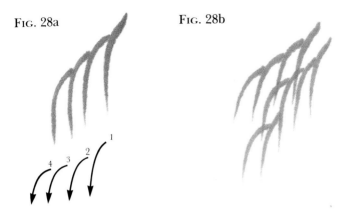

FIG. 29 A finished willow tree. The trunk is painted with a smoother line than for other trees, in keeping with the feminine aspect of the willow.

FIG. 29

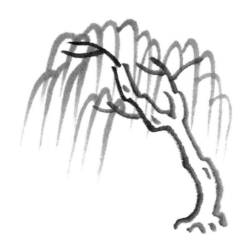

WIND AND RAIN LEAF PATTERNS

FIG. 30a Use an orchid leaf stroke, curved upwards or at both ends, to denote a tree in the wind.

FIG. 30b Here the ends of the orchid leaf stroke are curved down, for a tree in the rain.

FIG. 30a **FIG. 30b**

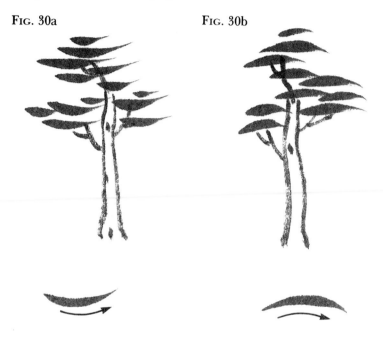

MIDDLE DISTANCE TREES

FIGS. 31a, b These have less detail with branches and simplified leaf groupings. Either one or two strokes can be used for the trunk.

FIG. 31a **FIG. 31b**

Figs. 32a,b A group usually consists of all the same type strokes, as less 'individualness' is observed at a distance, with varying heights and base points of trunks.

Fig. 32a

Fig. 32b

Fig. 33 This row of trees is incorrect, as it is too orderly to express the freedom of nature.

Fig. 33

INCORRECT

GRASS STROKES

Use a horizontal line of grass to balance the vertical line of trees. Placed at the base of a tree, a line of grass can help anchor the trunk to the ground. Also it can balance a tree that is top-heavy with a large leaf pattern.

Fig. 34 Needle stroke pattern.

Fig. 34

FIG. 35 Teardrop stroke pattern.

FIG. 35

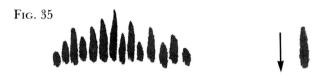

FIG. 36 Dot stroke pattern.

FIG. 36

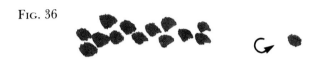

Within each grass grouping, the centre stroke is the largest with the shortest strokes on the edges.
FIG. 37 Shows a natural, undulating top line for a grass grouping.
FIG. 38 This is too symmetrical.

FIG. 37 FIG. 38

INCORRECT

If the grass moves in one direction with the wind, then all the grass strokes in that composition move in the same direction.

SIMPLE TREE GROUPS

First compositions

Usually different leaf patterns are placed on each tree in a group to enhance the character of each, with the host being more ornate. Sometimes, when expressing the qualities of a particular composition, all the trees may need to be of the same type, as in a pine tree forest.

All the following compositions have host, guest and servant trees.

FIG. 39 Paint all the trunks before adding the branches and the different leaf groups, pine tree, outline dot tree then the single dot tree. Then add the grass strokes.

Often outline and brush style leaf groups can be placed in the one composition for their contrasting balance.

The Chinese character is 'wood' but it can also be used for tree, painted in the stroke order shown.

FIG. 39

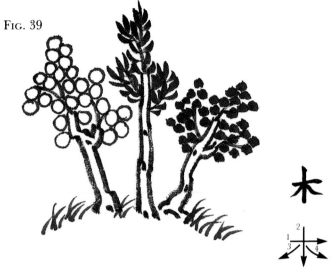

FIG. 40 A winter grouping. Paint the bamboo, then the pine tree, then plum blossom tree.

FIG. 40

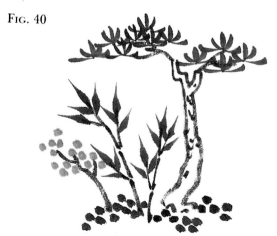

FIG. 41 A summer grouping. The tall Wu-Tung is balanced
by the sloping willow tree trunk.

FIG. 41

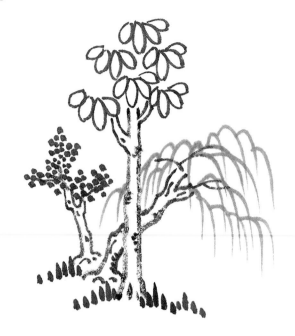

CHAPTER 7

ROCKS

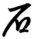

Rocks are the strongest, hardest elements of a landscape painting, so use the darkest, driest ink, with the thickest line. Hold an old red-haired brush on a very low angle, occasionally slightly changing the angle to produce a thick, but uneven line of bone strokes.

FIG. 1 Use a heavy, downward movement to make the first stroke of the rock from top to base.

FIG. 2 Paint the right side of the rock, also from top to base. Avoid the rock looking symmetrical by making one side longer and sloping it at a slightly different angle.

FIG. 1

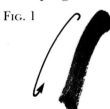

FIG. 2

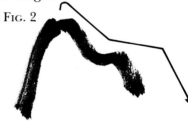

FIG. 3 Add a baseline in an uneven stroke to help form a roundness to the rock.

FIG. 3

FIG. 4 Not like this. Left and right sides are of equal length and angle instead of asymmetrical. Baseline is level instead of curved.

FIG. 4

INCORRECT

FIG. 5 Increase the roundness of the rock by adding texture strokes (wrinkles). These form planes on the surface of the rock, especially when placed at the base of the rock, which increases its heavy appearance. Use a dry, bent bone stroke, short and strong, for the texture (moulding) stroke.

FIG. 5

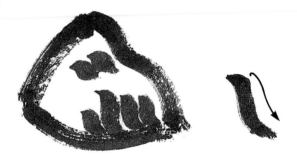

FIG. 6 A grey wash, black diluted with water, is added with a soft, white-haired brush. Apply over and slightly beyond the area of the texture strokes, to help mould the rocks.

FIG. 6

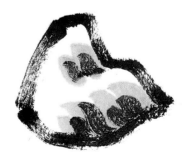

VARIOUS ROCK TEXTURE STROKES

Traditional names.
Unwoven rope wrinkles:
FIG. 7 Use a longer, more twisted version of the above texture
stroke.

FIG. 7

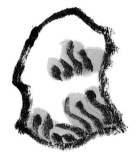

Raindrop wrinkles:
FIG. 8 The same as the leaf dot stroke but use drier ink.

FIG. 8

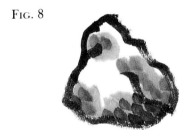

Lotus vine wrinkles:
FIG. 9 Like the willow leaf stroke but with dark ink.

FIG. 9

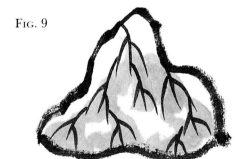

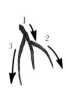

Small axe-cut wrinkles:
FIG. 10 Like bamboo needle stroke but the brush is loaded with dry ink and held at an angle.

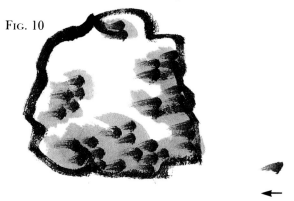

FIG. 10

Large axe-cut wrinkles:
FIG. 11 A longer version of the previous stroke.

FIG. 11

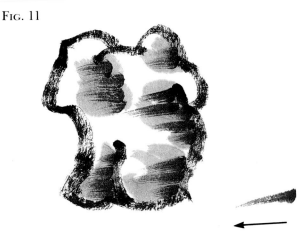

The outline of the above rocks enters inside the silhouette of the rock to form other planes and ridges. Some texture strokes are round or curved, for rocks eroded by water. Others are angular for those eroded by wind.

ROCK GROUPS

Within the one landscape composition all the rock texture strokes are usually the same.

A—Host B—Guest C—Servant

FIG. 12 Use an unwoven rope wrinkle.

FIG. 12

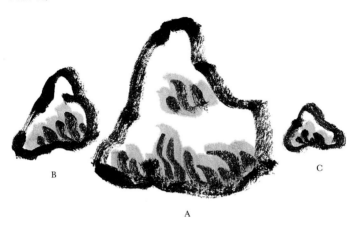

FIG. 13 Use a raindrop wrinkle. The Chinese character is 'stone' (rock). Paint in the stroke order shown.

FIG. 13

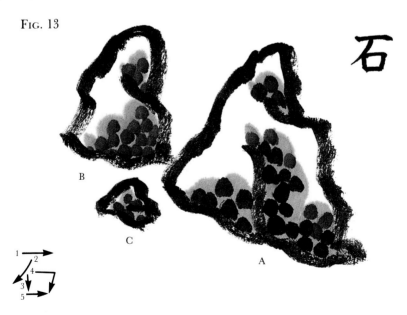

Fig. 14 Use a small axe-cut wrinkle.

Fig. 14

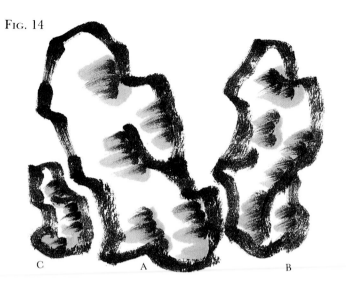

C A B

MIDDLE DISTANCE ROCKS

These are hills and nearby mountains. They have no baseline and this induces the feeling of height. The grey wash is brushed in a circular motion around the base so that the white paper appears to be gathered mist.

Fig. 15 Two hills; with unwoven rope wrinkle.

Fig. 15

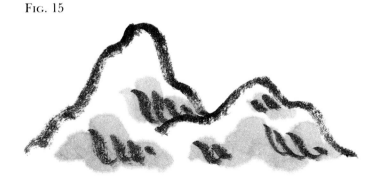

FIG. 16 Cliff peaks; using small axe-cut wrinkle.

FIG. 16

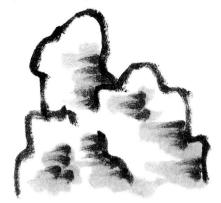

FIG. 17 A flat baseline is added where the effect of a distant shore needs to be conveyed. Later, water strokes will need to be placed beneath the baseline to visually 'hold down' the shore and bring it closer to the foreground.

FIG. 17

BACKGROUND MOUNTAINS

These are painted in brush style method, with no outline, to give them a less solid look. Load a white-haired brush with plenty of water. Then grey ink is loaded on to the top third of the hairs and then a little thick black ink is picked up on the tip.

FIG. 18 Use a soft bone stroke. Begin at the top of the peak, moving quicky to avoid all the wash being absorbed into the paper on the first stroke. Paint half way down the left side. Then return to the top while there is still some dark ink on the tip of the brush and paint the right side. Then return to

51

complete the left side. By then, the brush should hold mainly water with a little grey wash left. Use this to wash in the centre area of the mountain and to form the mist around its base by leaving the white paper showing where appropriate. The accompanying diagram shows the stroke movement and sequence.

Remember to keep the tip of the brush towards the edge of the mountain to obtain a sharp, clear edge. A little of the wash bleeding over the edge can look quite effective as rising mist or a row of trees.

FIG. 18a

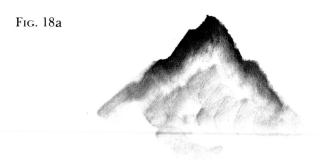

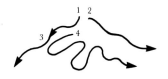

FIG. 18b

This is one of the most difficult techniques in landscape painting. It is equivalent to the painting of petals in flower compositions, requiring the same use of the soft, watered edges and a quick brush movement. Add a background mountain to most of your early paintings for practice, as it is useful for enhancing depth and height in a composition.

FIG. 19 A group of three mountains: A—Host B—Guest C—Servant. Leave a mist area of white paper between each mountain to increase the feeling of distance and loftiness. The character shown is mountain.

FIG. 19

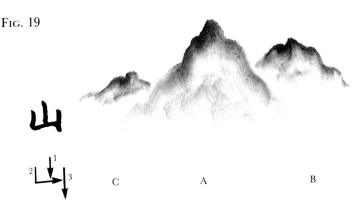

C A B

Rocks (positive) are important because when they are placed in a composition they also divide the paper into three white (negative) areas. These form the boundaries of water, mist and sky whose size and influence on the rest of the composition are dependent on the distances between foreground, middle-ground and background. The sky and mist are usually left just as white paper. The water area can include strokes of the same type from a variety of strokes for different moods, but can also be left blank as in the following compositions.

FIG. 20 Lake: Unwoven rope wrinkle. The path of blank paper, to enter and travel through the painting, begins at the bottom left, moves to the right, then turns to the left behind the foreshore. It then turns to the right to go behind the distant shore, then curves left up the hills and over to the distant mountains to the sky.

FIG. 21 Waterfall: long axe-cut wrinkle. Also used to paint the strokes for the rocks in the waterfall. All the rocks have no baseline to increase the feeling of being amid high mountains.

FIG. 20

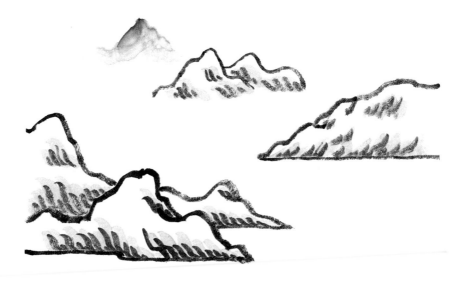

FIG. 21

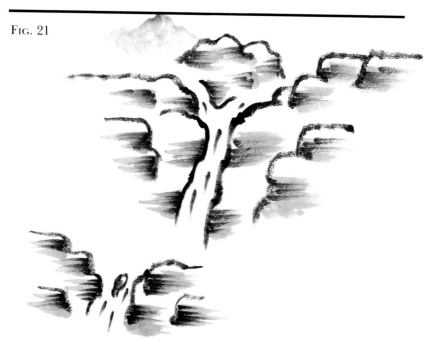

PEOPLE— BUILDINGS, BOATS AND FIGURES

The placing of human life in a Chinese landscape painting is one of the main reasons for creating the stage of trees, rocks and water.

People can be indicated merely by a secluded house, empty moored boat, deserted path, or bridge, or by a more positive indication with an activity appropriate to the season or setting. While not always essential, they are the most vibrant feature in a landscape, as a bird or insect is in flower painting.

This vibrancy is conveyed in a number of ways. By how the trees and rocks lean towards the buildings, how the water is placed for the boat to rest on, or how the distant hills are added for the benefit of placing a temple. It is also conveyed in the way the object is painted, by using taunt bone lines of dark ink and by using solid colour washes, often quite bright, for clothing. Thus a feeling of concentrated energy is conveyed. They should not be dominant in size, for people and their structures must never upset the balance of nature, but should merge harmoniously with it.

For all constructions use the principles of working from the foreground to background, from top to bottom and left to right. They should not lean but rather should stand well to weather the elements of the seasons and time.

To begin, use a fine brush as this is easier for producing the fine strokes required. It does not hold much ink, so with practice it can be better to use a larger, red-haired brush with a good tip. The bone stroke, as used for branches, is the main stroke used. It must be kept thin but strong, like strands of fine wire.

BRIDGES

Simple wooden bridge for streams:

FIG. 1 Paint a single bone stroke for the front edge of the bridge.

FIG. 2 Place a second stroke parallel with, but shorter than, the first stroke for the back edge of the bridge.

FIG. 3 Add the pillars in slightly thicker strokes to support the weight of the bridge.

FIG. 1 FIG. 2

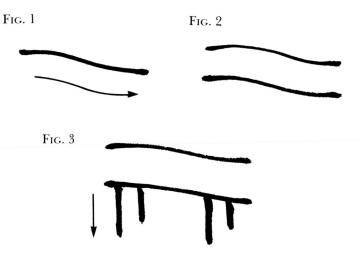

FIG. 3

FIG. 4 A more elaborate bridge: with side rail, for larger rivers, more traffic. Strengthen the rows of pillars with a crossbeam added afterwards.

FIG. 4

Stone bridge: for narrow but deep streams.

FIG. 5 Paint the top fore-edge of the bridge first.

FIG. 6 Add a back-edge to the bridge and horizontal lines for the steps.

FIG. 5

FIG. 6

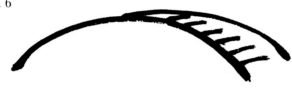

FIG. 7 Complete the archway in two strokes to show an underneath portion of the bridge.

FIG. 7

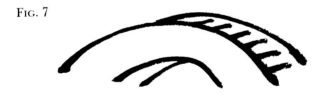

HOUSES

A simple farmhouse:

FIG. 8 Begin with the top of the roof.

FIG. 8

FIG. 9 Add the sides of the roof. Keep strokes two and three parallel.

FIG. 10 Add the wall lines a little in from the edge of the roof to form characteristic eaves.

FIG. 9

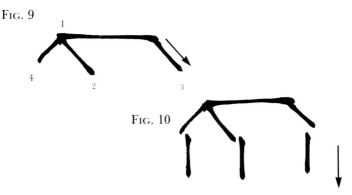

FIG. 10

All vertical lines for buildings should be kept parallel to the edge of the paper so that the building stands straight.

FIG. 11 Add short bone strokes to make a thatched roof.

FIG. 11

The windows and doors are the eyes and mouth of a building, too many shown will spoil its appearance.

Double-storey town building:

FIG. 12 Start with the top storey. The corner shown is the closest point of the building to the viewer and all the horizontal lines angle back from this.

FIG. 12

Fig. 13 Add the roof and walls of the lower storey. On each side of the building there are three sets of parallel lines, the horizontals, the verticals and the slope of the roof.

Fig. 13

Fig. 14 Add the lines to indicate the columns and top floor. Also add the doors and windows. These are of secondary importance to the structural lines of the building but represent its individual 'face'.

Fig. 14

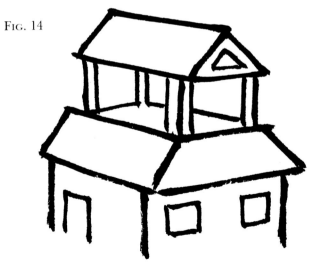

Fig. 15 Arrange a group of houses at various angles, to balance them through the host, guest, servant relationship. The sliding doors are open to the warm spring air.

Fig. 16 Houses in the distance show less detail. No doors or windows.

Fig. 17 Just the roofs show. Even these are partly hidden by the trees.

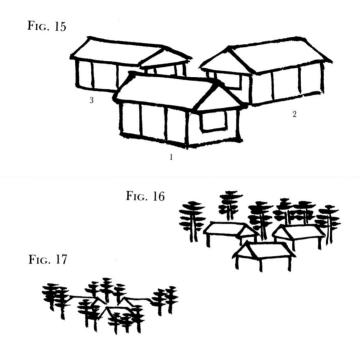

Fig. 15

Fig. 16

Fig. 17

Stone gateway:

Fig. 18 To the roof of the town house add the bottom of the stone bridge to construct a covered gate to town or temple complex.

Fig. 18

Summer pavilion:
FIG. 19 Only a roof with four supports, for protection from the sun or rain. Placed where there is an inspiring view. Poets will sit to share tea or to contemplate and compose.

FIG. 19

Pagoda:
FIG. 20 Paint a thin, vertical centre line, in a light tone of grey ink to assist you in keeping the tower perpendicular. This line will later become covered by the framework of the tower.
FIG. 21 Paint the top storey roof and walls, keeping the wall strokes parallel with, and equidistant from, the centre line.
FIG. 22 Add the next storey. The roof a little wider than the top roof and the walls a little further apart, but still equidistant from the centre line. Add the third storey in the same manner.

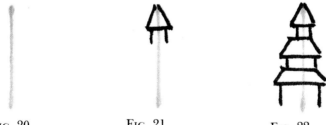

FIG. 20 FIG. 21 FIG. 22

FIG. 23 Add the spire, then the roof markings, covering over the centre line. The roof markings are at slightly wider angles the further away they are from the centre line, until they are parallel with the roof edge. The grey line showing on the walls will be covered with the coloured wash.

FIG. 23

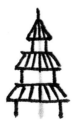

Fig. 24 Do not include all the storeys that exist in the actual building. Allow the bottom of the tower to be hidden by out-buildings and/or trees, to add mystique—all is not revealed.

Fig. 24

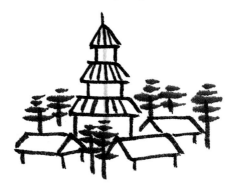

With practice you will eventually be able to construct a pagoda without needing the guiding centre line.

BOATS

Fig. 25 Begin with a slightly curved bone stroke for the main line of the deck.

Fig. 25

Fig. 26 Add both ends of the boat. There is no baseline as this is below the water.

Fig. 26

Fig. 27 Add a canopy, similar to the roof of a house, except use curved lines. The back arch of the entrance to the canopy is left raised to allow the back line of the boat to be placed in after it.

Fig. 27

FIG. 28 Add the mast and the deck planking inside the boat.

FIG. 28

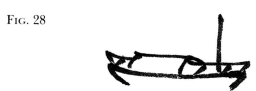

FIG. 29 A boat in full sail. Paint the sail first with the mast behind the sail.

FIG. 29

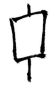

FIG. 30 Complete the rest of the boat as previously, then add any mast lines.

FIG. 30

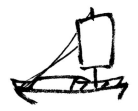

FIG. 31 As the boat recedes into the distance there is less detail. No mast lines. The inside of the boat cannot be seen.
FIG. 32 Further away, only the sail and hull line are visible.
FIG. 33 Only the top of the sails can be seen as the boats are hidden in the distant haze.

FIG. 31 FIG. 32 FIG. 33

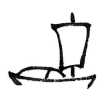

63

FIGURES

Human figures are usually painted relatively small in scale to the rest of the landscape but they are mostly placed at points of focal interest such as crossing a bridge between two land masses, in a boat on an expanse of water, or walking along a path that leads up a mountain side. Thus they can be used to move the eye through the composition from one area to another, either directly by pointing, or by guiding a boat, or indirectly, by facing into the composition or being at a point such as the edge of a cliff or beside a river that then takes the eye to the next area.

FIG. 34 Paint people from the head down. Begin with a short, thick bone stroke, with dark ink to form the hair.

FIG. 34

FIG. 35 With a fine brush, loaded with a grey tone (water and black), paint a single, curved orchid leaf line for a face in profile.

Usually facial features such as eyes and mouth are not added, as the landscape and the people within it are depicted as standard types, rather than particular individuals.

FIG. 35

FIG. 36 The rest of the body is painted in dark bone strokes. Paint the lines from the shoulder down to the hand, along the top of the arm and then the underside of the arm.

FIG. 36

FIG. 37 Paint the back of the body, then the front of the gown and its hem. For simplicity, the hands and feet can be hidden by clothing. The lines of the gown can be used to convey body movement. A bend at the elbow to convey arm action, and at the knee to express walking. Add a staff to indicate travelling.

FIG. 38 A person sitting can be placed on a boat, sailing or fishing; where there is a view, such as under a pavilion overlooking the lake; besides a waterfall; inside a building, looking out of a doorway or window. Paint as the previous figure, except with a wider, shorter gown as the legs are tucked up underneath.

FIG. 37

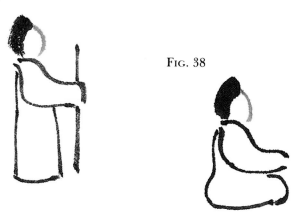

FIG. 38

FIG. 39 Groups of people. Paint host figure (1) then the guest (2). This will make it easier to keep the figures in proportion to each other. One speaks and one listens.

FIG. 39

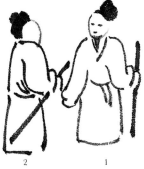

2 1

Fig. 40 A worker, fisherman or, in this example, a wood-cutter wears a jacket and leggings instead of a robe. If any skin area is shown, in this case a hand, it is also in a light grey tone like the face. Paint the figure from the hat to the feet, then add the bundle of wood.

Fig. 40

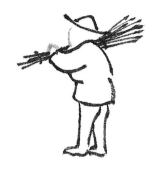

SEASON AND ACTIVITY

Spring - *joy*
strolling, talking, light work Active/Progressive

Summer - *peace*
resting, contemplating, drinking tea Passive/Expansive

Autumn - *melancholy*
travelling, heavy work Active/Returning

Winter - *solitude*
usually empty, hurrying home Passive/Withdrawn

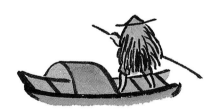

CHAPTER 9

WATER

The areas of water, mist and sky induce the calm and peace felt when viewing a Chinese landscape painting. After a congested area of overlapping trees of different types, a conglomeration of rock formations and areas of human activity. The eye/mind/heart is given a visual rest as it crosses the expanse of water/blank paper, before it reaches the distant shore. After climbing up through the forest slopes and visiting the temple, another rest is given with the presence of the shrouding mist, before a struggling climb to the mountain top where, having transversed the landscape, one rests in contemplation at the vastness of the firmament.

As explained in Chapter 4, water (the largest white area), sky and mist (the smallest white area) form a host, guest, servant relationship and are formed by the areas left when placing in the foreground, middle distance and background.

A minimum of line is used in these areas, mainly when it is needed to indicate the movement of the water. Thus, more lines for more active movement, as in rapids, and no lines for very calm water, or when the water is far away and such distinctions are not visible.

Use a new red-haired brush loaded with light grey tone. With a soft orchid leaf stroke, paint each body of water without reloading the brush to keep a consistency of tone.
FIG. 1 An orchid leaf stroke, the basic stroke for depicting water. Begin with the longest central stroke.

FIG. 1

FIG. 2 Add other shorter strokes, above and below the first line, making a sloped diamond pattern of calm water.

FIG. 2

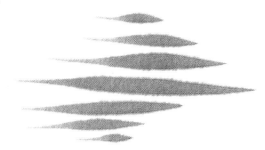

FIG. 3 Elongate the orchid leaf stroke and introduce a slight undulation to the line to depict a slight breeze passing over the water.

FIG. 3

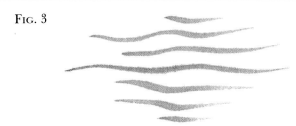

FIG. 4 Increase the undulations and turbulent waves are formed.

FIG. 4

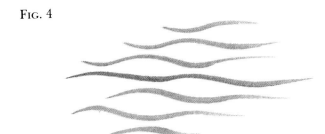

FIG. 5 Use a soft curving movement of the brush for flowing water controlled by a current, as around rocks, at the base of a waterfall or under a bridge.

FIG. 5

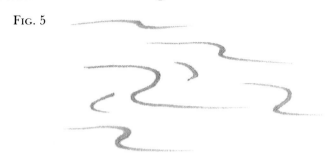

FIGS. 6a,b Use needle strokes that begin with a curve for the waterfall (the longer strokes) or for rapids. Both strokes are similar to the willow leaf stroke.

FIG. 6a FIG. 6b

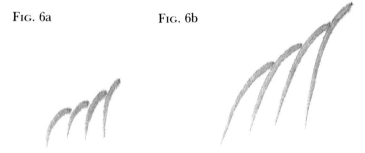

To capture the insubstantial quality of water, always use a light grey tone and a soft stroke. Don't cover the entire area with lines, but place lines only where it is necessary to emphasise its presence, for example, under boats, reeds, rocks, etc. to anchor them down.

COLOUR WASH

Practice of all the previous elements of Chinese landscape painting can be done on newsprint paper, but colour wash techniques can only obtain their full effects on the more absorbent rice paper.

The colours used in landscape painting vary slightly from those used in Chinese flower painting. The main difference is that, if it is possible to obtain the coloured, Chinese ink-sticks, the effort of grinding each colour will be repaid in the soft, translucent washes produced. The best source of supply would be a shop specialising in oriental art equipment (usually in Hong Kong, China, Japan, Korea or Taiwan). A well-stocked art shop or an oriental bookshop, or stationers, may have them, usually in sets but the more important colours sold individually.

As a compromise, a set of watercolours, oriental or Western, are fine either in tubes or pans.

Specific colours are listed below. Close equivalents of these colours (in brackets) are quite acceptable, for example, Prussian blue can be deepened with a little bit of black instead of using indigo.

RED: Alizarin crimson (*crimson lake, mid-cadmium red*), for clothing.

DARK BLUE: Indigo (*Prussian blue, ultramarine*). This is the main blue used. For water, to deepen rocks, leaves.

LIGHT BLUE:	Cobalt (*sky blue*), for clothing, tiled roofs.
YELLOW:	Gamboge (*mid-cadmium yellow*). Mixed with indigo to make various leaf greens. Not for clothing as it was the emperors' exclusive colour.
SAP GREEN:	(*Yellow green, mixed with dark blue and brown.*) Also suitable for leaves.
BROWN:	Burnt sienna and yellow ochre. Good earth colours for tree trunks, rocks, buildings.
WHITE:	Occasionally used for spots of falling snow (*fallen snow is indicated by the white paper left*). Do not use white to lighten tones as this will make them opaque, but rather dilute colours with water so that they remain translucent.

Dark blue and/or brown (not black) is used to deepen tones in the outline method so as not to distract from the black line. Black can be added to colours in the bolder brush style method.

PALETTES

Water colours do not sit well on a plastic surface, but tend to form into small puddles. A porcelain surface is ideal.

FIG. 1 For tube colours. Two small white saucers can be used to set up the indicated array of colours. The tree and rock palette can become mixed and muddied and then it will produce even more varieties of tone. Keep the clothing palette clean for soft, bright colours.

Leaf greens can be taken from the bottom of both palettes. From dark greens for pine tree, to bright greens for spring leaves, to autumn, orange tones.

FIG. 2 An oblong porcelain palette for pan colours, as used in Western watercolour painting, set up here for Chinese landscape painting. Like the chrysanthemum dish shown in the photograph, there are dividers to keep each colour separate.

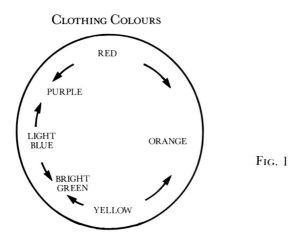

CLOTHING COLOURS

RED

PURPLE

LIGHT
BLUE

ORANGE

BRIGHT
GREEN

YELLOW

FIG. 1

TREE AND ROCK COLOURS

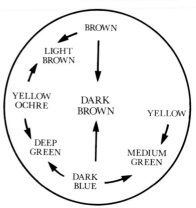

BROWN

LIGHT
BROWN

YELLOW
OCHRE

DARK
BROWN

YELLOW

DEEP
GREEN

MEDIUM
GREEN

DARK
BLUE

FIG. 2

INDIGO	BURNT SIENNA	YELLOW OCHRE	SAP GREEN	GAMBOGE	ALIZARIN CRIMSON
MIXING AREA					

Fig. 3

A. PALETTE (Chrysanthemum dish) With one arrangement of colours. Centre can contain water or, as here, black.

B. BOX OF COLOURED INK-STICKS with a small white dish for grinding each colour in, with a small amount of water. Because they are softer than the black ink-stick they do not need an ink-stone.

C. PACKETS OF POWDERED COLOURS These have to be mixed with water and the medium, glue, and ground in a mortar and pestle.

D. TUBES OF WATERCOLOURS The three primary colours in shades equivalent to the oriental colours. Blue-indigo. Red-alizarin crimson. Yellow-gamboge.

All these types of colours can be reconstituted with water when dried.

E. WASH BRUSHES (of goat hair). Medium and large size. Both will come to quite fine points when wet. The loop on the end of the large brush is so that the brush can be hung from a special brush stand to dry.

F. TWO SEALS The seal with the rabbit on the top has an image of a rabbit carved on its base. The seal with the water buffalo on the top has the characters 'One together' on its base, as used in Fig. 1 Chapter 15.

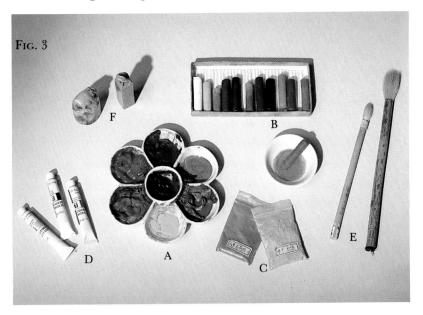

Fig. 3

FIG. 4 Traditional porcelain palette dishes, stacked together with a lid on the top, usually in groups of three or five.

FIG. 4

The coloured ink-sticks can be ground on any of these types of palette. Whatever the palette is, it should be shallow enough to allow easy access for the brush to stroke on the colour at a low angle, but deep enough to contain a fair amount of colour wash.

COLOUR WASH—BRUSH LOADING TECHNIQUES

Refer to this section as needed until the basic principles are understood.

First load the brush (of white-hair unless otherwise stated) with water, dabbing off any excess on the side of the water container. Add the first colour mentioned and then any other colour mentioned, the amount of each colour and quantity of water will vary with the requirements. There are basically two different ways of loading colour on to the brush. One way is that the first colour is equal in amount to the second colour and together they produce a third colour. The other way is that the first colour is mixed with only a little of the second colour to produce a deeper tone of the first colour. The second

colour should be a little thicker than the wash and is placed on the tip of the brush where it will not mix too readily with the other colour on the brush.

Notice that there is a simple principle of adding from the lighter tones to the darkest. Because of the number of different aspects involved, including brush type, amount of water, types and tones of colour, their amounts on the brush and their interaction, each brush load will produce its own varients of colour and tone. But with practice and time you will gain the experience to be sensitive to the occasion.

Exercises

FIG. 5 On a piece of rice paper, paint an outline of a rock and give it a simple wash of yellow ochre mixed with burnt sienna, on the top portion (where there are no texture strokes).

FIG. 5

Apply the wash in one continuous movement for each area, as indicated by the arrows. Control the wash so that it does not bleed over the outline, by using the brush at an angle when washing the middle of the rock. Where the colour meets the outline use the brush on its tip for more exact control of the flow of the wash.

FIG. 6 For the base colour, mix indigo with a little burnt sienna and wash it over the texture strokes and slightly over the first wash, which would still be damp. The two washed areas should blend naturally together.

FIG. 6

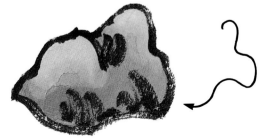

Fig. 7 A colour wash over a leaf group. Load the brush with water mixed with a little sap green and dip the tip of the brush in slightly diluted indigo. Paint from the top left corner to the bottom right in one continuous flowing motion, as indicated. The wash goes beyond the edge of the leaf group, but maintains an uneven silhouette.

Fig. 7

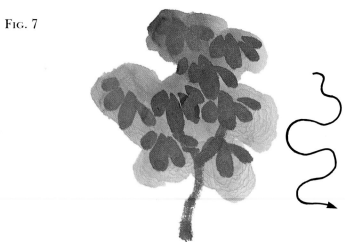

Fig. 8 For outline leaves, each leaf is coloured with one movement keeping within the outline.

Fig. 8

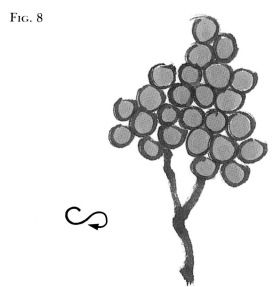

76

CHAPTER 11

FOLIAGE DOTS

These dots are the eyes of the painting. And just as in bird and animal painting, the eyes are placed in last to bring the subject to life. They are added when the colour wash is almost completely dry so that they slightly blend in.

FIG. 1 A round dot. Using an old red-haired brush held upright and loaded with wet, dark ink, produce each group with a series of quick single-pressure strokes.

FIG. 1

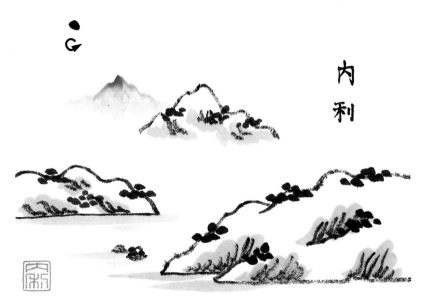

The foliage dots are placed throughout the composition in diminishing sizes and tones as they recede to the background. They create a visual unity between the different land masses and are also used to break up the long horizontal lines. The dots on the rock edges direct the eye back to the next level.

FIG. 2 Round dots again, repeating the motif of the leaf strokes and holding down the tree and rock by adding visual weight to their bases. The light-toned dots in the foreground, behind the rock edge, form small bushes. Dots to the right of the rock lead across the canyon to the distant mountain.

FIG. 2

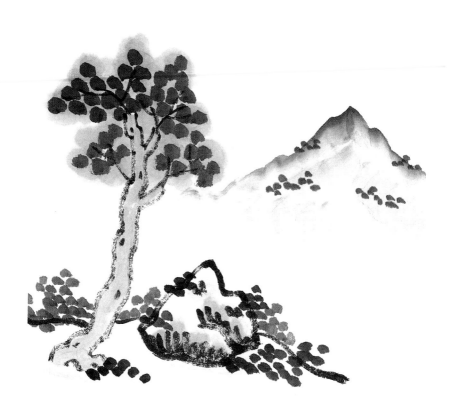

FIG. 3 A vertical teardrop dot, with the brush angled away from the body. The dot represents grass on the rocks, that lead the eye down to the dots representing reeds, that direct the eye across the composition to the far shore where there are dots for trees. The vertical foliage dots balance the long horizontal baselines of the shores of the lake.

FIG. 3

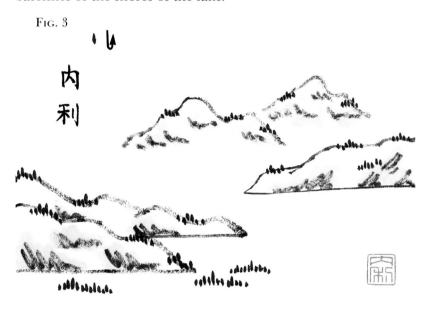

FIG. 4 Horizontal dots, used as the main constructional element of a small composition. First paint the roofs of the houses, then cluster the foliage dots around them. Load a soft white-haired brush with water, then grey ink, then dark ink. Hold the brush at an angle and paint the horizontal dots left to right. As you paint the various tones will appear. Paint each cluster with one load of the brush. Move slowly, allowing them to blend together for a misty, mountain forest effect. This style was used by Mei-Fei (Sung dynasty) many years before 'pointillism' of the French Impressionists.

A painting is complemented with a piece of calligraphy which can be an inscription, a poem, a dedication or merely the date and the artist's name. Then the artist seal, in strong vermillion ink, is added to further balance the composition and to authenticate the work.

Fig. 4

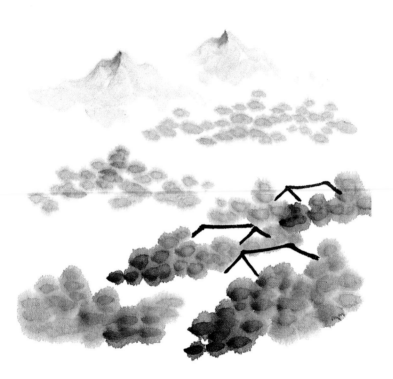

The characters in Figs. 1 and 3 are Nay-Lee, my Chinese painting name. The seal has the same characters in an older script, most often used on seals. The area around the characters has been carved out, leaving the characters raised in relief, so that it stamps red ink on a white background.

The calligraphy and seal will be further explained as they are introduced into each composition in later exercises.

CHAPTER 12

BAMBOO WATERFALL

A step-by-step construction of a complete Chinese landscape painting.

The individual techniques for painting each subject— bamboo, rocks, water, colour wash, foliage dots, etc., are explained in each relevant chapter. Some of the information is repeated because of its importance. Refer to Fig. 11 for the positioning of each subject in the total composition.

FIG. 1 Use a red-haired brush loaded with dark, wet ink. Hold the brush on a slight angle from upright and, with a downward bone stroke, construct the main stem. Then add the branches.

FIG. 2 Complete the bamboo grove in the order shown.

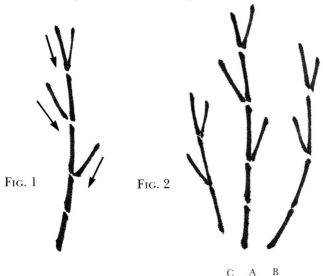

FIG. 1 FIG. 2

C A B

Fig. 3 Add a leaf group pattern for old bamboo. Use an upright red-haired brush loaded with dark, wet ink. Paint needle strokes to construct a leaf group, starting with the centre leaf and working towards the outside ones, at higher angles and shorter. Place each leaf group harmoniously to the other leaf groups, in a pattern of five as in the spots on a dice or dominoes.

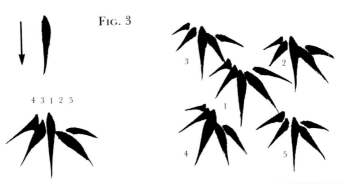

Fig. 3

Fig. 4 When adding the leaf groupings to the stems, take care to make an irregular silhouette for a natural appearance.

Fig. 4

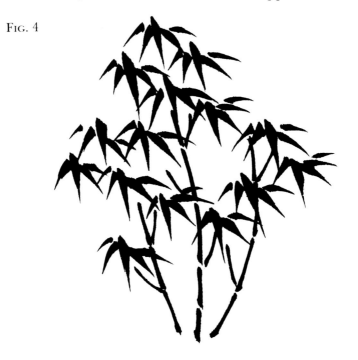

FIG. 5 Use a low-angled, red-haired brush with dark, dry ink. Paint a downward, right-to-left stroke to begin the rock. Construct the rocks left side, right side, then the base. Add the texture strokes of unwoven rope wrinkles. Completed rocks should look rounded and heavy.

FIG. 5

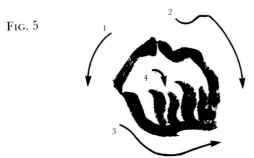

FIG. 6 The middle distance is completed as shown, making sure the baseline, where the shore meets the water, is level.

FIG. 6

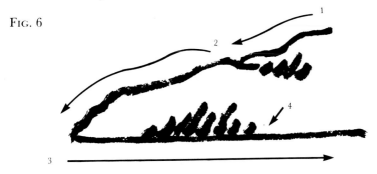

FIG. 7 There are no wrinkles or baseline for the distant mountain.

FIG. 7

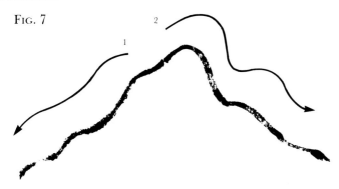

Fɪɢ. 8 Add the rocks from the foreground to the background in the order shown, to form a horizontal perspective. Be attentive to the spaces left, for these are the water, mist, and sky. Make sure there is enough space at the top of the composition for the mountains to be comfortable.

Fɪɢ. 8

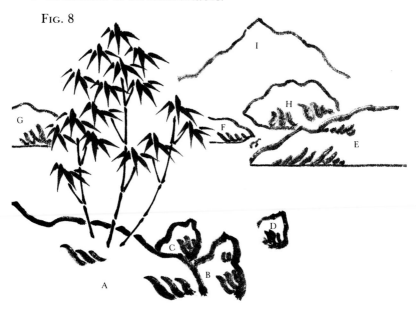

Fɪɢ. 9 Use an upright red-haired brush with pale, wet ink. Paint a water stroke with a downward needle stroke that curves at the beginning but doesn't curve back upon itself. The lines of the waterfall are painted from the centre line out to the edge, as shown.

Fɪɢ. 9

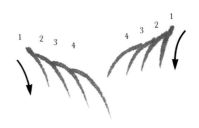

FIG. 10 The grass stroke is painted similarly to the water stroke, but with an upward movement in dark, wet ink. This stroke is also not too curved. Start at the centre of each grass group and work towards both edges, in irregular descending height.

FIG. 10

FIG. 11 When adding the water and the grass to the composition, do not use too many strokes. Let the viewer imagine the rest. Make sure all the grass is blown in only one direction. The rhythm of its movement is repeated in the waterfall. The painting could be considered finished at this stage.

FIG. 11

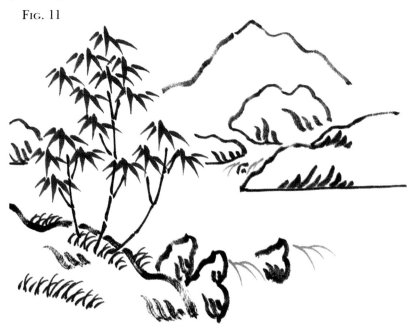

FIG. 12 Add the colour wash with a soft, white-haired brush. Begin with the bamboo, loading the brush with a wash of sap green and tipped in indigo. Paint additional stems then wash over the leaf pattern in three movements, re-tipping the brush in indigo each time. The start of each movement is where the indigo appears on the finished example. Paint over the grass strokes with this same colour.

FIG. 12

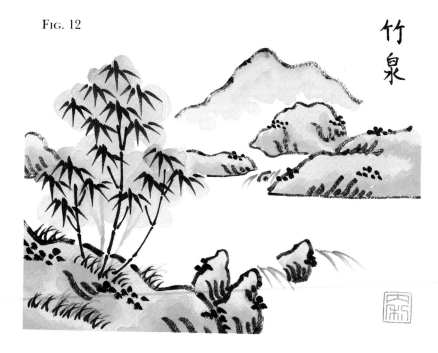

Colour the rocks in the same order as they were outlined. Yellow ochre mixed with sap green for the tops, burnt sienna mixed with indigo for the bases. The background mountain is in a burnt sienna wash tipped in indigo. Use the wash to form the top edge of the mist. Use a pale indigo over the water strokes. Add dark, vibrant, round foliage dots where they are needed to enliven the composition.

FIGS. 12a,b The calligraphy is 'bamboo-waterfall', painted in the stroke order shown. The seal is placed in an appropropriate position for balance.

FIG. 12a

FIG. 12b

Fig. 13 This is a reversed view of the above composition. Just a grey wash has been added to mould the rocks and leaf pattern, producing a more placid scene.

Begin with the grove of bamboo in the right foreground before adding the rocks beneath it, then paint the middle distance on the left before painting the background mountains—the very distant ones with no texture strokes. Add the waterlines, then the grass before the grey wash, and when this is dry add the foliage dots.

Fig. 13

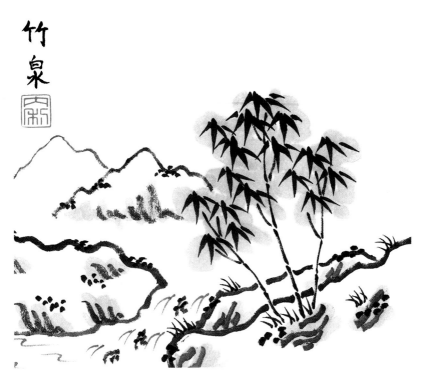

FIG. 14 A more complex design with young bamboo. Take the top of the bamboo above the hill lines. Paint the bamboo in the middle distance before adding the background rocks. There are no water lines on the water in the distance.

Repeat the bamboo strokes in sap green tipped in indigo. Allow the colour wash on the inside edge of the right-hand rocks to taper away, producing a mist encroaching effect. The distant mountain is painted in a water wash tipped in indigo. Use teardrop foliage dots.

Observe that the placement of calligraphy and seal in each composition still maintains the harmony of the design.

FIG. 14

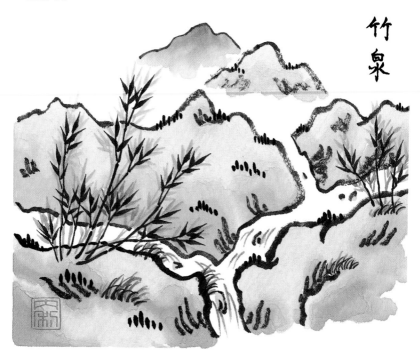

CHAPTER 13

THE THREE PERSPECTIVES

In Western landscape painting, evolving from the scientific outlook of the Renaissance, the scene is viewed with a level perspective, as if seen through a window. There is a single vanishing point on the horizon.

This is also an important perspective for Chinese landscape painting and the one that is used in all the previous examples in this book. But there are two other perspectives used, and sometimes the different perspectives are combined in the one painting. These are found especially in the horizontal scroll form, and are used to induce a sense of movement in the position of the viewer, as if they too were involved in actually travelling through the landscape. (A scroll example is shown in Chapter 17.)

LOOKING-DOWN PERSPECTIVE

This is the perspective most associated with Chinese landscape painting. It is most used in the hanging scroll form. It is a birds-eye-view, as if the artist and viewer were aloft in a balloon, although it was established well before such flights. There can be a number of horizons, each higher up the composition than the last, each unfolding another view of great expanses of water and scenery.

LEVEL PERSPECTIVE

In the Chinese presentation of this perspective there are no trees half cut-off by the edges of the painting, as may be portrayed in a Western landscape composition, which dominate the foreground, excluding the viewer from entering the composition and remaining a passive observer. Rather there is a 'platform'

of rock or water which is to be used, by the viewer, to enter the scene with active, imaginative participation.

LOOKING-UP PERSPECTIVE

Here the top of the foreground rock face is cut off by the top edge of the paper or shrouded in mist, producing the effect of nearby towering heights. Often the horizon line is hidden behind the rock face, enhancing the closed-in feeling.

All three perspectives contain a movement of vertical composition that alternates up the paper, from one side to the other and leads the viewer back into the scene to the distant mountains and then brings the viewer back down into the centre.

LOOKING-UP PERSPECTIVE

FIG. 1 An early winter scene: the figure is within the house, which is sheltered by the rock face. The boat is moored until spring.

Begin by painting the pine tree trunk, with a strong root system and dragon scales. Let it bend well down to lead the eye into the composition. Add the branches and the leaves.

Paint a rugged rock face from the top edge of the paper to the rock's base. Place a ridge line under the roots of the pine tree to anchor the tree to the rock. Rock texture strokes are small axe-cut wrinkles.

Paint the edge of the path in a narrower line but still with dry ink. Place in the vertical side of the path, leaving space for the boat. Paint the small rocks on the path and the ground strokes under the rocks' base. Leave the base of the shore line until after the boat has been placed. Paint the boat as previously shown in Chapter 8, adding a balancing, vertical line for the mast and cross-hatching, for a woven-cane effect, to the canopy.

Tie a line from the boat to the small rock on the path. Add in the rocks in the front of the boat and paint the base of the shore line and the vertical texture strokes on the side of the path. These are also axe-cut wrinkles.

Paint in the houses, the front house first, from the top of the roof down to the balcony and then much thicker strokes for the supporting stilts. Then place in the figure.

Add the rocks in front of the house. Then begin the middle distance, the rock (far shore), then the pine trees. Add the reeds with an elongated teardrop stroke, its direction of movement, a slight lean to the left, leading the eye in to the composition.

FIG. 1

松

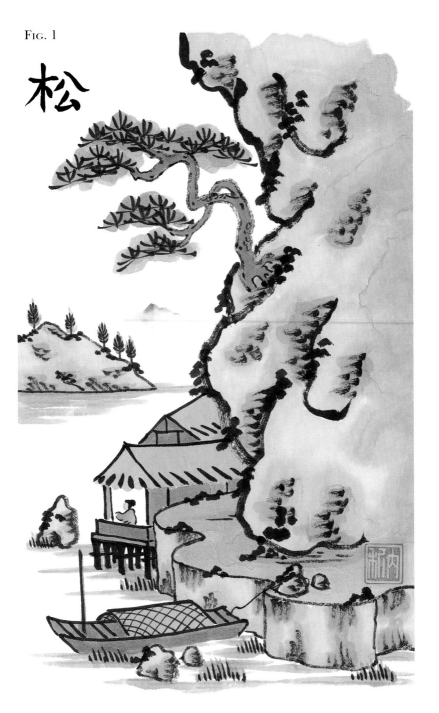

Fig. 1a This shows the visual movement of the linear elements in a spiral motion that keeps the eye within the composition—from the boat A, to the path B, to the centrally placed houses C, up the rock face D, then along the tree trunk E, and back down the branches and leaves F, returning, with the distant shore line G, to the centre.

Fig. 1a

Having painted all the black outline, add a grey wash to enhance the stronger subjects and to produce more tonal values when the colour wash is painted. Add the grey wash over the leaf pattern to the tree trunk, over the texture strokes to mould the rock forms, onto the base of the balcony and the side of the back house and also inside the boat to give depth to the hull. With the same grey wash use a long orchid leaf stroke for the water lines.

Colour wash: by using a few base colour washes and slightly changing their tones with additions of these same colours, many tones can easily be achieved while maintaining tonal harmony.

Apply the washes in a similar order as when painting the outline. But, for ease of working and unity of tone, when a particular colour wash has been mixed, use on all the same coloured subjects where possible. Mix enough wash to finish the required areas. Do not be concerned to reproduce exactly the same colour and tone as in the examples as each palette of colours will vary.

If the wash begins to run over the outline, change the backing sheet to soak up the excess paint and prevent it from spreading more. Often a small area of wash that has overrun the outline can later be covered with the foliage dots.

Sometimes there is a small area of grease on the rice paper that does not absorb the wash. Painting over this area a second time should remedy this.

Wash colours used: burnt sienna with a little indigo for all the tree trunks, the sides of the houses, the balcony, the side of the boat and its decking and to reinforce the stilts of the houses and the mast of the boat.

Dilute this wash with more water to obtain a wash some tones lighter. Apply this to the top edge of the rocks and the side of the path. Fade the wash into the top edge of the paper for a mist effect. Add indigo to this wash to deepen it and apply it to the base of the rocks, overlapping the lighter wash slightly.

Load the brush with a wash of sap green and indigo and then tip the brush in a little more indigo, washing over the pine tree leaves and painting more strokes over the reeds. With this wash on the brush, tip the brush in a wash mixture of burnt sienna and indigo and apply it to the path, starting over the texture lines.

Use a yellow ochre wash for the roofs of the houses and the boat canopy. Dilute this wash with more water to achieve a pale tone for the face of the figure.

Use a wash of indigo and a little burnt sienna for the insides of the buildings and the boat. This blue represents a peaceful atmosphere inside. Also use this wash over the water lines. And then add a far-distant wash mountain with the brush tipped in indigo.

Transfer the rice paper to a dry under-sheet and allow the wash to almost dry before adding round foliage dots. Use the foliage dots positively, to hold down the trees and to mask the area where the houses go behind the rock face and bring this area of rock forward. Also use the foliage dots to strengthen any weak points in the rock outlines.

Fig. 1b Add the calligraphy for pine tree in the stroke order shown.

Fig. 1b

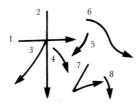

The seal in all three compositions in this chapter also reads Nay-Lee, but the characters are beside each other instead of on

top. They have been carved into the stone so that white characters on a red background are produced when it is stamped.

In Figs. 1 and 2 the composition has a tendency to lean over to the left. The vivid bold seal in the right lower corner stops it from toppling over.

LEVEL PERSPECTIVE

FIG. 2 Springtime: the boat sails slowly out beyond the headland and the path leads up to the pavilion where there is an expansive view.

FIG. 2

Begin with the group of three trees in the right foreground. They are placed in the harmony of host, guest and servant. Then paint the rock plateau behind the trees, leaving the back edge of the plateau until after the pavilion and the nearby trees have been added. Place in the secondary (guest) rock to the right. The texture stroke is small axe-cut wrinkle.

Paint the path and its sides and the small rocks on the path and in the water. Paint the trees on the plateau and the pine tree on the cliff face. Add the houses and pavilion, then the back line of the plateau and the small pine trees.

Now add the far shore and its pine trees. Add the boat in full sail. Then the background mountains.

Paint the reed strokes, more vertical and tranquil in this composition.

FIG. 2a The movement of this composition begins in the right foreground. From the path A, the eye ascends the trees B, then moves along the line of rock C, where the two trees D on the plateau lead across to the distant hills E, then the pavilion F begins the descent to the pine tree G, leaning over to the distant shore H, then back across the water on the boat I, to the houses. This movement can also flow in the reverse direction.

FIG. 2a

Add a grey wash to the pine tree trunks and to the dot leaf tree trunks, as well as over the rock texture strokes. The water strokes are thicker to indicate a more placid mood.

Colour wash: a wash of burnt sienna and indigo is used for the trunks of all the pine trees, as well as the balcony of the house, the hull of the boat and the pillars of the pavilion.

Deepen a yellow ochre wash with burnt sienna for the other tree trunks, the roofs of the houses and the boat canopy. Different tones will appear as some areas have an underlying wash of grey.

Use a wash of sap green and indigo for the leaves of the pine trees and all middle distance tree leaves. Add more sap green to this wash to paint over the foliage of the dot leaf trees and reeds. Add a little burnt sienna to this mixture for the leaves of the Wu-Tung tree. Then tip this wash in a little more burnt sienna to paint the grass on the foreground riverbank and on the plateau.

Use a wash of yellow ochre and burnt sienna for the top edge of the foregound rock, the side of the riverbank, the side of the house and the roof of the pavilion. Deepen this wash with indigo to paint over the texture strokes of the rocks and those on the side of the riverbank.

Use a wash of yellow ochre with a little sap green for the top of the distant shore and hills. Use the same colour for their bases, as in the foreground rocks.

The boat's sail is in cobalt blue.

Use indigo for the insides of the house and boat canopy, for the background wash mountain and over the water strokes, where they should merge together to form broad areas of colour.

Add plenty of small round foliage dots for the abundance of the season.

Fig. 2b The calligraphy is Wu-Tung, in the stroke order shown.

Fig. 2b

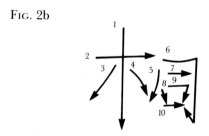

Fig. 2 takes the viewpoint of Fig. 1 further back. Fig. 3 recedes it even further.

LOOKING-DOWN PERSPECTIVE

Fig. 3 Autumn brings the boats homeward.

As there is no true foreground, treat the closest subjects as in the middle distance.

FIG. 3

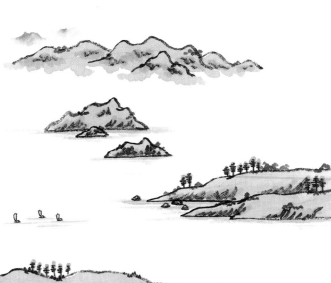

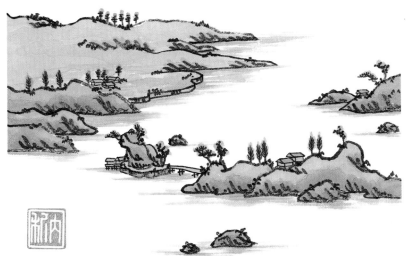

Paint the rocks from the front, right across to the left-hand shore, then the other right-hand shore. The texture stroke for all the rocks is a simple, dry bone stroke, as there is less character seen at this distance. Add the trees and buildings. Then the right far shore, the islands and the background mountains. Add the boats.

FIG. 3a There is an ascending spiral movement in this composition, decreasing as it moves up the paper. Rocks A lead to the mansion houses B, across the bridge C, to familiar pine tree island D, over to the fishing village E, where the long headland takes the eye across to the opposite headland F, where the trees direct the attention back across the water to the pine grove G, then over the water, with the aid of the boats H, to the far shore I, and island J, up to the distant mountains K.

FIG. 3a

Add a grey wash to the base of the rocks, the roofs and the balconies of the houses, and as a fine line for the water.

Colour wash: burnt sienna and indigo for the top of the rocks in the foreground. Deepen this wash with more indigo for the base of the rocks and the side of the shore line.

Use a less diluted wash of burnt sienna and indigo for all the tree trunks, the roofs and balconies of the houses, the pillars of the houses, bridge and pavilion, and for the boat canopy.

Lighten a wash of burnt sienna with yellow ochre for the walls of the houses, the top of the bridge and the roof of the pavilion.

Use a sap green and indigo wash for the pathway, on the plateau, the flat area around the village and for all the leaves on the trees on the front line of rocks. Add more indigo for the leaves of the more distant trees.

The rocks behind the village and beyond are washed in diluted versions of the tones used for the front rocks. This will recede them into the composition.

Add the indigo wash for mountains. Also use fine lines of indigo for the water, extending these lines further out from the shore lines to lead the eye between the land masses. Apply a second wash over the water where it is close to the front line of rocks to pull them forward. Add smaller round foliage dots; those in the background are of a medium grey.

FIG. 3b The calligraphy is the more formal word for tree. The character is more complex and can be visually divided vertically into thirds, rather than into halves, as the other two characters in this chapter.

FIG. 3b

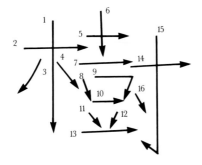

THE FOUR SEASONS

Simplified colour use:

SPRING:	yellow–green	*willow tree, rain*
SUMMER:	blue–green	*bamboo, warmth*
AUTUMN:	yellow–brown	*maple tree, wind*
WINTER:	blue–brown	*pine tree, cold*

As stated in Chapter 1, Chinese landscape painting developed its characteristics during the Sung dynasty and reflects the styles, philosophies and attitudes of that time when, without modern conveniences, the seasonal changes had a larger influence on the pattern of life. Thus they were the important themes to paint.

The more temporary weather influences, such as rain, wind and snow, are mostly only used where they help to induce the particular mood of the season.

Often all four scenes are placed side-by-side as hanging scrolls or on different panels of the one screen.

Renditions of the four seasons are shown in the following examples, where the same landscape is portrayed under each season. It is the soft (yin) elements, such as the willow leaves, the water and the people, that are most influenced by the seasonal changes. The firmer (yang) elements, such as the tree trunks, the rocks and the buildings, are mostly affected over the larger expanse of years.

There is a harmonious repetition in the lines of the steps of the path and the steps of the bridge and on the roof of the house.

Refer to the relevant chapters for more details of each subject.

SPRING

FIG. 1 A suitable title for this composition could be 'setting out on a short journey, after the rain'.

This is the simplest of the four compositions.

Begin by painting the willow tree trunk, then its branches, then the trunk and branches of the guest tree. Add the leaves of both trees in a light ink, willow leaves, then the dot leaves. Keep both trees sparse for the new growth of spring.

FIG. 1

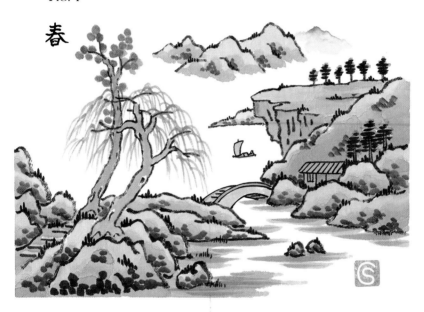

Paint the foreground rocks from the left-hand bottom corner to the right-hand side of the paper, then the plateau, the distant shore and the background hills.

Add raindrop wrinkles to the rocks. Then place in the steps of the path, the bridge, the houses and the boat. Add the pine trees, then the water lines. There are no water lines in the area beyond the bridge to convey a wider expanse of water.

Colour wash: use a wash of yellow ochre mixed with a little burnt sienna for the willow tree trunk and branches. Use this also for the front side of the bridge, the boat canopy and for the top of the steps on the path and on the bridge. Paint the

willow tree leaves with a wash of sap green tipped with cobalt blue. Use a red-haired brush and paint coloured strokes over the grey strokes adding more strokes to give depth to the leaf pattern.

Use burnt sienna with a little yellow ochre for the trunk of the guest tree, also for the handrails of the bridge, the side of the step on the bridge, the side of the house, the hull of the boat and for all the pine tree trunks. Deepen this wash with indigo for the underneath of the bridge, the base and the sides of the steps on the path and roof of the house. Dip this wash in a little more indigo for the vertical side of the plateau.

Mix sap green and yellow ochre and dot over the guest tree leaves, adding some more leaves. Also use this for the shutters on the house. Mix this wash gamboge yellow for the sail of the boat. Then dip this wash in burnt sienna for the grass area on the plateau, starting from the right and painting to the edge.

Use indigo with a little sap green for the closer pine tree leaves.

Use yellow ochre with sap green for the top of the rocks and use burnt sienna and indigo for the base of the rocks. Use indigo inside the house and under the boat canopy, for the more distant pine tree leaves, for the far distant wash mountain and to expand the water lines.

Add an abundance of the teardrop foliage dots.

Fig. 1a Add the character for spring.

The seal is my initials S C in a monogrammed dragon design.

Fig. 1a

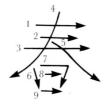

SUMMER

Fig. 2 'Long days of tranquil contemplation.'

Specific differences for the construction of this composition are: add a full growth of leaves on to the willow tree before placing in what can be seen of the guest tree trunk. Add a full growth of dot leaves in dark ink.

More of the inside of the house is exposed to the sun's warmth. After painting the front line of the hull of the boat and the canopy, add the figure before completing the rest of the boat. The water stroke is a finer, more tranquil line.

FIG. 2

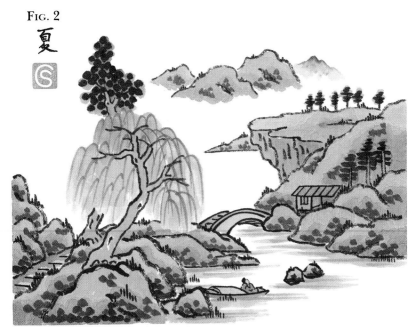

Colour wash: use sap green tipped in cobalt to wash over the full foliage of the willow tree before applying a wash to the guest tree trunk, whose foliage is painted with a wash of sap green tipped in indigo. Paint the gown of the figure in alizarin crimson and the undergarment in cobalt. Use yellow ochre diluted with water to give a soft tint for the face. The top of the rocks are in sap green mixed with indigo and their base burnt sienna mixed with indigo. The background mountain is a little clearer. The water is in indigo mixed with cobalt.

FIG. 2a Add the character for summer.

FIG. 2a

The seal is placed in the right top corner to balance the red of the gown in the left bottom corner.

AUTUMN

Fɪɢ. 3 'Welcoming the traveller.'

秋 Fɪɢ. 3

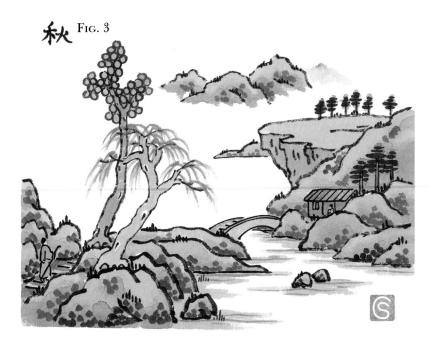

The leaves of the willow are sparse, the guest tree leaves in outline style. Paint the traveller after the front rocks, but before the rocks behind him and before the path strokes. Add the figure inside the house after its completion. Use a fine undulating line for the ripples on the water.

Colour wash: the leaves of the willow are painted in overlapping strokes of sap green mixed with yellow ochre. Use a mixture of gamboge and alizarin crimson to make an orange wash for the autumn tonings of the guest tree leaves. The traveller's gown is in alizarin crimson. The figure in the house wears a gown coloured in a cobalt blue.

Use yellow ochre with burnt sienna for the top of the rocks. Use burnt sienna with indigo for their bases. Use yellow ochre with sap green for the plateau. Use indigo with a small amount

of burnt sienna for the water. Add only a few foliage dots and reeds. The dots used to indicate pine trees on the distant hills remain unaffected.

FIG. 3a Add the character for autumn.

The seal is again used to balance the red tones in the painting.

FIG. 3a

WINTER

FIG. 4 'The first snow covers the land.'

Leave appropriate gaps on the willow tree trunk, on the boat canopy, bridge and the roof of the house, for the snow to sit. Both trees are bare of leaves and there are just a few strands of twigs on the willow. Add the wood-cutter after the front

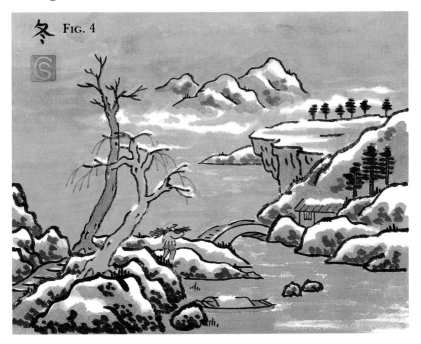

冬 FIG. 4

rocks, but before the rocks behind him. The sliding door of the house is closed.

Give the rice paper a wash of grey, leaving white areas of paper to indicate the snow and mist.

Colour wash: when the grey wash is dry, add the colour washes, taking care to leave the white areas free of wash. The colours will take on more sombre tones due to the underlying grey wash.

Colours for the tree trunks, the bridge, the boat, the house and the pine trees are the same as previously. The entire side of the house is painted in brown as the door is closed. Use a wash of indigo and burnt sienna for the base of the rocks and the side of the plateau.

The figure has a yellow ochre straw coat, an indigo jacket underneath and burnt sienna for the hat, leggings and the bundle of wood.

The water is given an almost all-over indigo wash, leaving just some broken areas for ice. As it proceeds to the background, the indigo wash is diluted with more water to fade it as it rises into the mist, but it is strengthened again above the background mountains. No far wash mountain is shown as it is hidden by the mist. Add a few foliage dots only where necessary as accentuating marks.

Fig. 4a Add the character for winter, when the wash is dry.

Fig. 4a

To round off this presentation of the seasons there follows a traditional list of seasonal division:

The beginning of spring—Rain water—The waking insects—The spring equinox—Pure brightness—Grain rain.

The beginning of summer—Grain full—Grain in ear—The summer solstice—Slight heat—Great heat.

The beginning of autumn—The limit of heat—White dew—The autumn equinox—Cold dew—Frost descent.

The beginning of winter—Slight snow—Great snow—The winter solstice—Slight cold—Great cold.

And then the cycle begins again.

BRUSH STROKE STYLE

This style is distinctive in its use of single, broad brush strokes, using direct colour, to give a more dynamic, emotional quality, especially in the rendition of tree trunks and rocks. This is in contrast to the quieter, refined elegance of the black outline and soft colour washes of the more traditional style so far depicted in this book.

The single brush stroke style is a more recent development and parallels the rise of flower and bird painting in the 16th century which is now mostly painted in the single brush stroke style. This is more suitable for giving animation to the birds and vibrancy to the flowers. Flower and bird painting can also be carried out effectively in the outline style, especially for the more refined and complex subjects such as storks, peonies, and other large birds and flowers. They are often painted on silk, as landscape can also be.

For this style, the quality of the paint is thicker than the washes previously used, but still fluid enough to be moved easily across the rice paper. As there is no black outline, black is often combined with the other colours for the deeper tones.

THE THREE FRIENDS
Pine tree, plum blossom tree and bamboo

FIG. 1 While each of these subjects can be placed individually in many different landscape or flower compositions, when placed together they traditionally symbolise three suitable companions on a long (life) journey. Plum blossom for Hope, bamboo for Strength and pine tree for Long life.

Load an old red-haired brush with burnt sienna mixed with indigo, dab the brush on the cotton cloth to take off any excess

FIG. 1

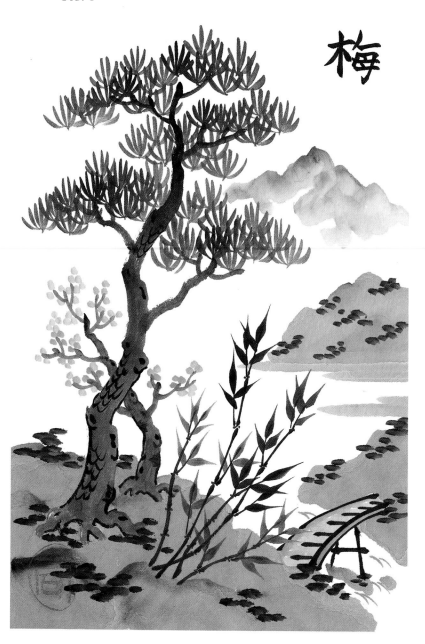

梅

water, then tip the brush in black. Hold the brush at a slight angle from upright.

Fɪɢ. 1a Paint from the top of the pine tree trunk downwards, in a series of connected bone strokes. For each change of direction apply a little more pressure to produce the stronger, knuckle-like joints. As the brush moves down the trunk, gradually increase its angle to slowly thicken the trunk. After completing the main trunk add the branches and wide, strong roots. The branches are thinner at their tips and thickest where they join the trunk. Make sure they are connected firmly to the trunk. This is best achieved by slightly overlapping each branch on to the trunk.

Fɪɢ. 1a

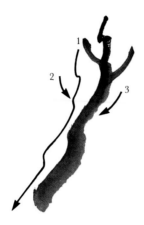

With an upright, red-haired brush, loaded with wet, dark black, paint the dots on the trunk, indicative of knotholes. Add a strengthening, bone contour line where it is needed. Complete the trunk with scallop-like scales for the bark.

Paint the pine leaves with an upright, red-haired brush loaded with sap green mixed with indigo and tipped in black. This is so that after some leaves are painted the black will have been used up and lighter toned leaves will appear. Paint cone-shaped pine leaf groups as shown in Fig. 18 Chapter 6, but with a thicker needle stroke. Use the same pattern and groupings as in the outline style.

Next add the plum blossom tree in burnt sienna mixed with yellow ochre, from the top of the trunk to the roots, using the same techniques as for the pine tree. Make the trunk less rugged

for a softer aspect and with no scales, but just some cross markings on the trunk. Add the plum blossoms with a white-haired brush loaded with a little water and then tipped in rose madder (a pink-red), though any red will do (e.g. alizarin crimson). Use a round leaf dot stroke to paint a sparse gathering of blossoms, each dot one flower. Allow the red to be worked off the brush and soft watered dots to appear. Retip the brush in red as necessary.

Add the young bamboo with a red-haired brush loaded with sap green and tipped in black. Paint the bamboo as described in Fig. 25 Chapter 6, but with thicker strokes. After painting the stems, add an accentuating bone stroke across the bamboo joints to strengthen them. Add the leaves in groups of three but only put two where it is necessary to avoid a crowded appearance.

FIG. 1b Before adding the foreground rocks, practise this simplified example. Load a white-haired brush with a wash of burnt sienna mixed with indigo and then tipped in black. Hold the brush on a low angle and paint a very thick bone stroke from top to bottom for the left side of the rock, then add a second jagged bone stroke for the right side, then a third stroke for the rock's base, filling in any white paper left with additional strokes.

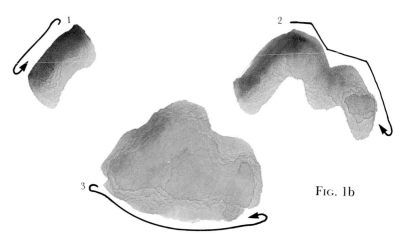

FIG. 1b

Now add the foreground to the composition, in a series of ridges, painted from left to right, under the bamboo, then just behind the pine tree and under the plum tree. This ridge forms the edge of the rock face where the bridge is. Just paint over

the bamboo stems where necessary and when the wash dries it will appear as if it is behind the stems. There is a third ridge on the left side of the composition, further behind the pine tree and just behind the plum tree. There are no baselines to any of these ridges.

Before painting the other side of the creek add in the bridge. Load a red-haired brush with wet, black ink. With an upright brush paint a thick bone stroke, left to right, for the front edge of the bridge, then add the back edge and the steps, then thicker strokes for the pillars and supporting beam. Refer to Fig. 3 Chapter 8 for a simplified version of a similar bridge with more instructions if needed.

Now add the other shore with a ridge under the right end of the bridge. Add a baseline for the water's edge. Add the top edge of the shore, working down from the right to the left. Add another ridge along and over the end of the bridge. Add a rock to support the pillars and a guest rock next to it.

Then add the distant shore, starting in the middle top and working down right to left to the baseline, then the rest of the top from left to right, to the edge of the paper. Then add the baseline and fill in any gaps.

To a white-haired brush loaded with water, add a small amount of indigo wash tipped in a little black and paint the far mountain, the left side then the right side, and then work down to create a mist-encircled peak. With indigo, add in needle strokes for the rapids and broad orchid leaf lines for the distant water.

When the rocks are almost dry add horizontal foliage dots, left to right, with a red-haired brush loaded with sap green and tipped in plenty of black.

The brush style method is similar in many ways to the outline method, except that only single, much broader strokes are used instead of two finer strokes for the outline.

FIG. 1c Add the calligraphy for plum tree.

 FIG. 1c

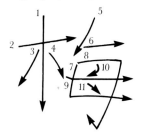

The seal is the characters 'one together' (referring to painting and calligraphy), in an uneven oval design. Both this seal and the one in Fig. 2 have a boldness in keeping with the character of the brush style landscapes.

The illustration on the front cover and gatefold is also of the three friends but in the outline style, begun in the left bottom corner and worked towards the right top corner.

PINE TREE RETREAT

Fig. 2 The brush style technique is well suited for this composition of rugged, mist-shrouded hills and mountains set behind a cluster of buildings. Usually, in a brush style, buildings are painted in outline to emphasise their geometrical qualities, but with a thicker, freer line than in the traditional way, as in the bridge in Fig. 1. But in this composition the houses are painted in the traditional outline method. The stark grey-tiled roofs and white walls contrast with the browns and blues in the freer wash style pine trees and mountains. Again a balancing of opposites as when brush style leaves are used in an outline painting.

Fig. 2

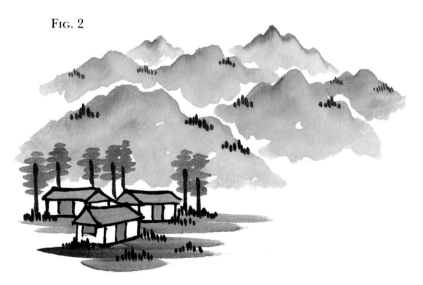

Begin with the houses. The construction of a group of houses is explained in Figs. 8 to 15 Chapter 8. Use a wash of indigo for the doorways and windows. The grey roof colour is actually made from a mixture of indigo with a little burnt sienna and black.

Then add the pine tree trunks in burnt sienna mixed with black. The leaves are in indigo mixed with sap green. Add the ground lines in burnt sienna mixed with indigo and tipped in black. Use an orchid leaf stroke from right to left. Touch up the strokes to bring them up to the houses.

Add the closest hill on the left, with a diluted wash of sap green tipped in burnt sienna. Bring the wash down around the pine tree tops but leave some white paper above the houses as the first line of mist. Then add the hill to the right in burnt sienna tipped in indigo. Leave a thin, uneven line of white paper between each hill to create mists caught in the valleys. The next line of hills are in burnt sienna mixed with indigo then tipped in more indigo. Start with the centre ridge, then the ridge on the right side of the brown hill, then the ridge on the far left. Finally, add the background mountains in a wash of water tipped with indigo.

Add teardrop foliage dots of sap green tipped in black, working from the foreground to the background. There are no trees shown on the background mountains.

The right side of the foreground is left vacant to balance the congestion of the houses, the pine trees and the mass of hills and mountains. The viewer can imagine a mountain lake, a cliff edge or just some rolling mist.

The seal has the characters Yee-Ma. This seal forms a pair with the seal used in Chapter 13. Together they stamp the completed statement Yee-Ma Nay-Lee, loosely meaning peace is within you, from which my painting name is derived.

Any of the outline paintings in this book can also be rendered in the brush style method.

Also develop the skill to reverse a composition as this can be a first step towards the ability to form your own compositions. Try both of these techniques on the other paintings in this book and you will have many more examples to work from. If you have difficulty in reversing a composition, first paint the composition as it is shown, then turn over the rice paper and the painting should show through enough to use as a guide until your own visual perception improves.

SPRING LANDSCAPE

FIG. 3 This is a reverse composition in brush style of the outline spring landscape in Fig. 1 Chapter 14, painted in the same construction order, but from right to left.

FIG. 3

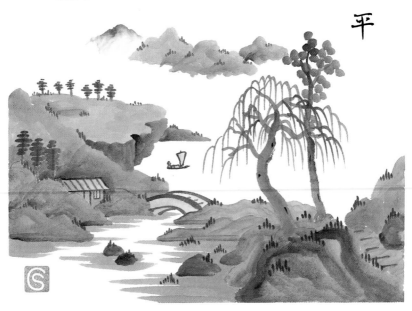

The main differences are that there are no outlines to the tree trunks and the rocks, and no grey leaf patterns and water strokes, but rather there is an immediate approach to both subject and colour, directly to the heart (essence).

Paint the willow tree trunk in yellow ochre mixed with burnt sienna tipped in black. The guest tree is of burnt sienna and indigo tipped in black. Willow leaves are sap green mixed with cobalt tipped in black. Guest leaves are sap green tipped in black.

For the rocks, first load the brush with yellow ochre mixed with sap green, then load burnt sienna mixed with indigo on the half of the brush nearest the tip, and then tip the brush in black.

Paint each rock with one brush load, gradually lessening the amount of black as you work towards the background. The

plateau is sap green tipped in burnt sienna. The cliff face is burnt sienna mixed with indigo and tipped in black.

The house, the bridge and the boat outlines are of burnt sienna tipped in black. Use the same colour washes as in Chapter 14.

The small trees are also in the same colours as in Chapter 14. Add the water with indigo using broad orchid leaf strokes. Add teardrop foliage dots in sap green tipped in black, paint all the dots with the one loaded brush so that they are just in sap green in the background.

Fig. 3a The Chinese character is peace.

Fig. 3b

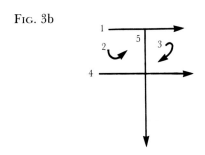

CHAPTER 16

SOME PRACTICAL USES

Besides producing traditional Chinese landscape paintings to be framed, as well as making interpretations of actual scenes, the techniques described in this book can be used to decorate many varied articles and surfaces. Always use the same brushes but alter the paint depending on the requirements of the surface.

One of the most difficult concepts to obtain in Chinese painting is that of composition—where to place the various visual elements and where to leave the empty spaces. In this chapter, designs are presented in a variety of formats to help you in this understanding. Study each example to comprehend the visual balance of 'just enough'.

Designs Fig. 1 to Fig. 5 are composed from elements contained in the hand scroll depicted in Chapter 17. The designs have been rendered in black and grey to emphasise their simplicity, but appropriate colours can be used as desired.

The Chinese calligraphy is all characters that have been used previously in this book.

Here are some circular designs suitable for decorating plates for potters or porcelain painters, each using the medium best suited to them:

Fig. 1 Bamboo mountain.
Fig. 2 Pine tree study.

These designs could also be painted on rice paper and then a circular mat cut and placed around them.

Two more designs, in an oval pattern, for similar use:

Fig. 3 Secluded house by the river shore.
Fig. 4 Wind-swept tree, perched on a cliff top. (A dragon about to take flight.)

All four compositions make effective use of the visual space.

Fig. 1

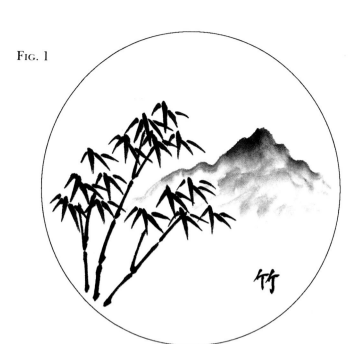

Fig. 2

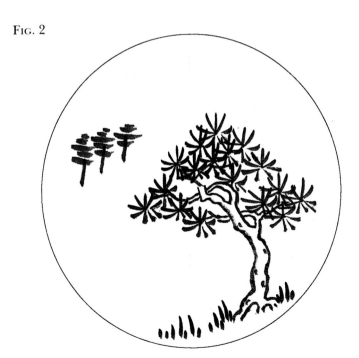

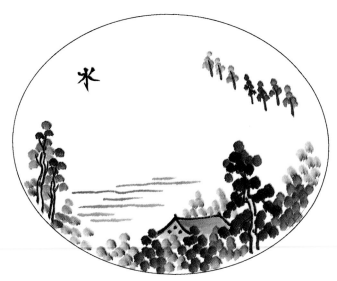

FIG. 3

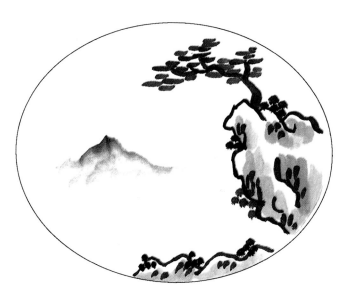

FIG. 4

Two oblong designs suitable to wrap around cups, vases etc:
Fig. 5 Country cottage. The principles of host, guest and servant apply to the three trees, which have a leaf stroke that is produced by holding a red-haired brush on an angle and painting a short, triangular needle stroke that is thicker than the pine needle stroke.

Fig. 5

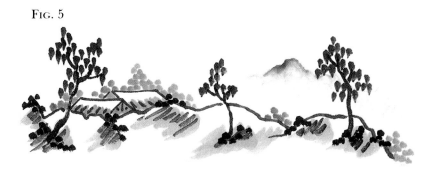

Fig. 6 Dwelling in a glade. The single tree will appear on the opposite side of the vessel from the house.

Fig. 6

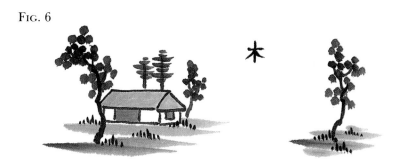

PORCELAIN PAINTING

Two views of a cup handpainted by Peg Swiney, a porcelain artist who studies with me. This example shows how she has adapted the techniques of Chinese landscape painting for her own art, in this case especially, with the principle of the empty/full balance of space and subject.

FIG. 7 Shows a tree that leans over a bridge, that leads to a mass of houses of a waterside village, and is balanced by the visual space on . . .

FIG. 7

FIG. 8 . . . the opposite side of the cup, where the middle distance island floats on the river, and the eye stretches back to the far mountains.

FIG. 8

Harmonious colouring is achieved by the simple use of red and green only (the brown being a composite of these two colours).

Here are two examples suitable to apply to gift cards. When working directly on to the board, use less water in the mixing of the colours to avoid blotting, as it is less absorbent than rice paper.

With such a small area to work on it is better to reduce the number of elements in the composition rather than to crowd everything together.

FIG. 9 Sailing in summer.

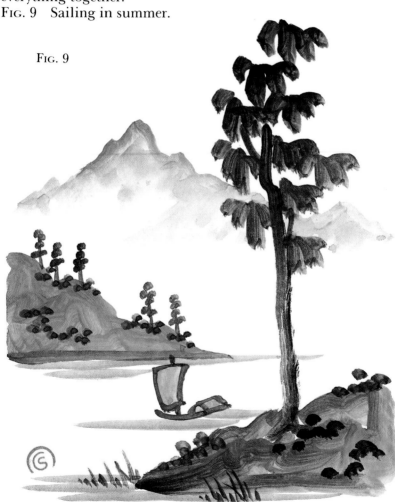

FIG. 9

FIG. 10 Rapids amid the pine mountains.

FIG. 10

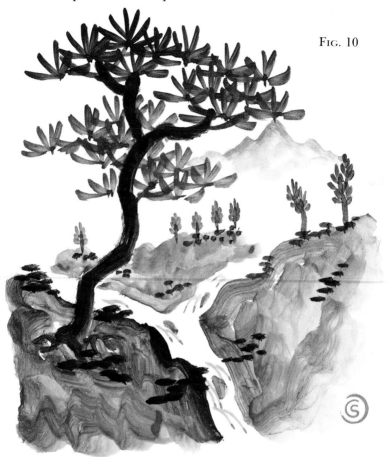

Place a smaller motif inside each card, such as a boat or a hillside of trees, in one corner.

Both of these cards contain the monogrammed S C design in a circle, not completely stamped here. This seal is different from the others in being carved into brass.

The next three illustrations are paintings of the three friends in close study, brush style, which is how they would be shown in flower painting, included here with landscape elements for contrasting balance.

Again these designs are composed in a circular format suitable for painting or pottery, etc.

Fig. 11 Bamboo and water (strong-gentle). Two aspects of endurance through flexibility.

Use the same strokes as for the landscape bamboo, but with longer leaves, painted with the whole arm to help keep them straight. Then add the water lines.

Fig. 12 Pine tree and mountain (near and far). The pine tree and the mist around the mountain are both symbols of awakening dragons, in form and texture.

Fig. 11

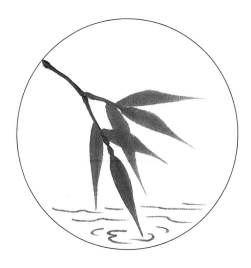

Fig. 12

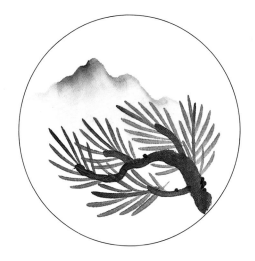

FIG. 13 Plum blossom and rock (fragility and ruggedness). Both contain aspects of beauty.

FIG. 13

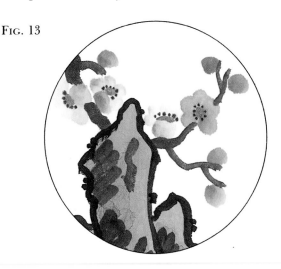

Paint the rock first, its roughness accentuated by using the outline technique. Paint the branch next, and contrast both with the soft flowers. This is achieved by using a white-haired brush loaded with a little water and tipped in rose madder (red/pink). Paint round dots for the buds, then the five-petalled open flowers. Add green centres and when dry, add small pollen dots in black.

PAINTING ON T-SHIRTS

A water-based, fabric (silk screen) paint obtainable at most art shops will be needed. It is best if the T-shirt is 100% cotton. If using a new T-shirt, first wash it to remove the starch coating they are given. When it is dry, iron out the wrinkles and insert a sheet of cardboard, or several sheets of clean newsprint paper inside the T-shirt, behind the area you are going to paint, so that the design does not bleed through to the back.

Using the Chinese brush, mix fabric colours with the reducer, an opaque medium made by the same company that makes the fabric colours. This will help to prevent the colours from bleeding on the highly porous cotton. Water can then be added to dilute as necessary, but the more water that is used, the more chance that bleeding will occur.

Practise on an old T-shirt to learn to control the flow of paint. The single brush stroke method is best for ease of working, but often after placing in the brush stroke, it does not register fully on the T-shirt owing to the thick texture of the fabric. So reinforce the stroke by going back slowly over it, allowing the paint time to absorb into the material. Do not make it too thick as then it could crack or peel off later.

When the design is finished, insert clean paper to stop the paint sticking to the other paper where it has soaked through the material. Then allow the T-shirt to dry before curing the paint by hot ironing on a cotton setting, for about five minutes. Various fabrics and their curing requirements are usually listed on the paint container.

This method can be adapted to other garments and materials. It is especially effective on silk, which takes the brush strokes more easily but tends to bleed more easily too. Synthetics tend not to absorb the paint. A fixer, made by the same company, can be used to help the fabric paint bond to the material.

FIG. 14 A very simple, basic design suitable for a first attempt.

FIG. 14

The host tree leaf strokes are horizontal dots. The dry effect produced by the paint not absorbing into the cotton is ideal for the trunks and this area has not been reworked.

The signature in the corner was written with a fine black laundry marker. An oil-based seal ink would wash out. The laundry marker can also be used for some outlining techniques but is limited in its versatility of expression.

Any of the designs in this chapter would be most suitable to transfer on to a T-shirt.

Washing hints: To help reduce the fading of the colours, hand wash the garment in cold water, use no bleach and dry the garment in the shade, or turn the design inside out.

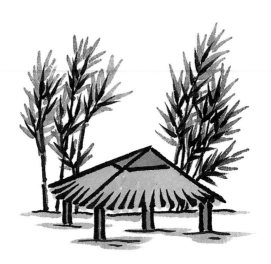

CHAPTER 17

STUDYING FROM THE CLASSICS

The following extracts are taken from a copy I painted of a scroll by a Japanese artist, Sesshu (1420–1506), who excelled at landscape painting in the Chinese style (a Japanese name for this style is sumi-é). I copied this scroll as a study of various landscape techniques, painting a section at a time, first the black lines, then the grey wash, before moving on to the next section. Each section is a natural break in the composition, as the sections are presented here.

While it may be possible for you to make a visual study of each section, it may be difficult to maintain that study for a couple of hours (the time it took to paint each section). More learning can be absorbed through actually painting and it is more enjoyable. A finished painting is a satisfying result as well.

This scroll depicts a scholar and his apprentice travelling through a classical Chinese landscape. They are not only moving across the 'space' of the composition, but are also progressing in 'time'. The scroll begins in spring with the travellers setting out. They journey on through summer and autumn crossing rivers and mountains, meeting people, staying in temples, cottages and towns, until they arrive, at the start of winter, at their destination, a large, walled city in which to spend the cold season. Just at the close of the scroll there is seen a path beyond the city wall, that winds up and around a cliff face to disappear behind an over-hanging rock, and which entices them to continue the journey.

The story unrolls from right to left and should be viewed only one section at a time. In these reproductions the ends of

each section have been repeated to convey the continuity of the original scroll. The copied scroll is 7.5 m x 20 cm. Each section length is approximately 25 cm.

The illustrations that follow depict one full section each of which, on the scroll, would be viewed as the left side was unrolled and the right side was rolled up over a rod.

FIG. 1 This is also the start of the scroll.

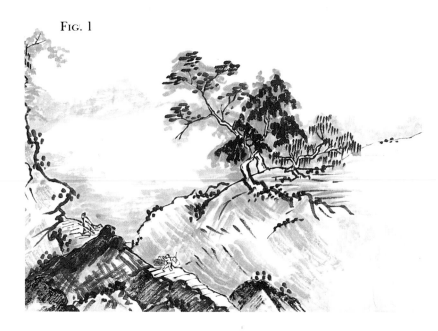

FIG. 1

The group of trees, host, guest and servant, directs the eye to the left, to the path that leads further into the scroll, leading up and into the composition with the forward movement of the boy inviting the viewer to see where he is going.

The rock texture strokes used throughout the scroll are long axe-cut wrinkles. The host tree uses a rough teardrop stroke for the leaves.

FIG. 2 The figure in the lower right continues the theme of the last section and, with aid of the path, the viewer is led through the tangle of rock. There is a host rock just in front of the figure, the guest rock is above and behind the host rock with the servant rock in the left foreground. There are three groups of trees, with the group on the far left pointing towards the next section.

Fig. 2

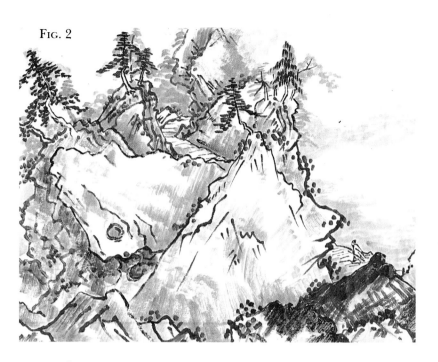

Fig. 3

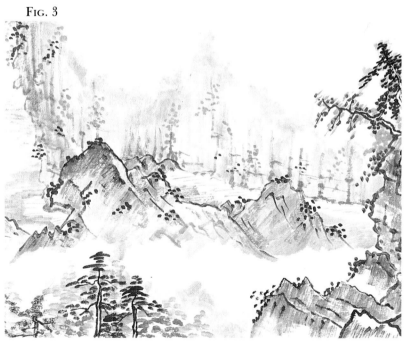

Fig. 3 This section is a moment of visual rest with much empty space and little detail to tire the eye. It is a looking-up perspective whereas the first section has a level perspective and the second includes level and looking up perspectives. The path maintains the theme and the left to right movement. The trees in the lower foreground lead the viewer into the next section.

Fig. 4 A rest for the travellers, at a country estate, as a wind springs up. This is a looking-down perspective. The large host building is on the left, the guest building on the right, and a cluster of servants gather around the host. Again, it is the trees that lead into the next section.

Fig. 4

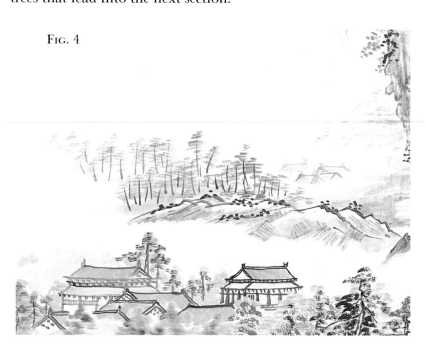

Fig. 5 Continuing the journey through a grove of pine trees. A fine study of twisted trunks and branches and of pine leaf patterns. This section presents a level perspective. Spring turns into summer. The guest tree on the left leans across into the next section.

Fig. 6 A cluster of cottages is a reason to pause for a cup of tea. The path reappears. The trees on the left have a triangular leaf pattern in outline style. A looking-up perspective.

FIG. 5

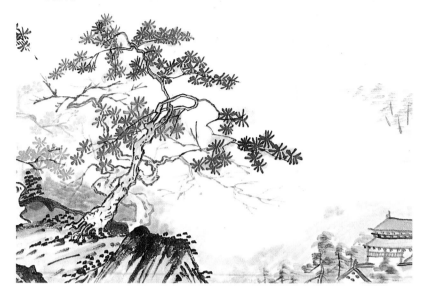

FIG. 6

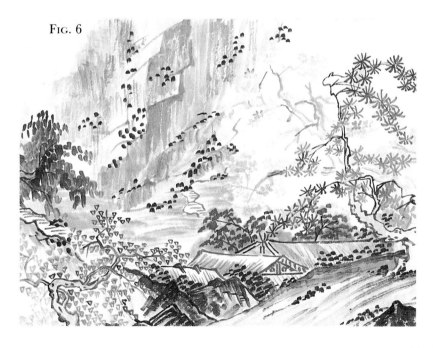

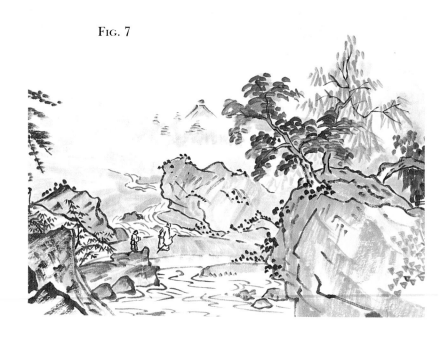

FIG. 7

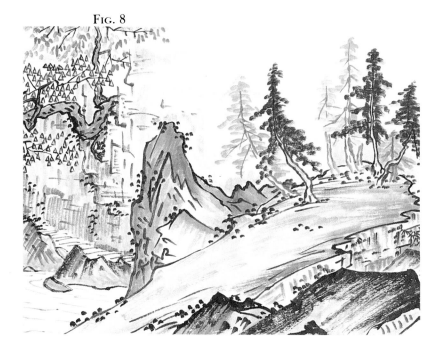

FIG. 8

FIG. 7 The tree group starts in the last section and carries across into this section, looking down on the path, now a stone slab bridge with a bamboo grove on one bank. The river winds away to the distant mountain. The travellers turn to farewell someone who had accompanied them from the cottages. The emptiness in the distance relieves the composition from the closed-in sections on either side.

FIG. 8 The tree group directs the eye on the downward slope to the water at the lower left. There is a level perspective on the right, changing to a looking-up perspective on the left. The path leads around a rock face to the next section.

FIG. 9 It is early summer at a prosperous lakeside town where the roofs are tiled. Willow trees and rocks gather on the water's edge. The travellers prepare to embark on a ship taking them to the opposite shore.

The amount of scroll in all the sections shown is about one-fifth of the scroll's total length.

FIG. 9

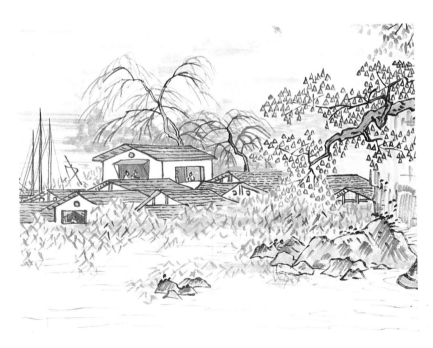

THE THREE ARTS

Painting portrays the image,
Poetry expresses the meaning.

The poems are rendered in fine calligraphy which is as artistic and revealing as the painting and poem. The words of each poem reflect the symbolic meaning of the visual image; the grace of line in the written words is repeated in the form of the subject.

Here are some examples using some of my poems in Western calligraphy to illuminate the harmonious contribution of each art in creating a unity of expression.

SPRING

FIG. 1 The painting portrays the visual influence of wind and rain on the trees and the earth. The first two lines of the poem repeat this imagery. The last two lines state some of the results.

To paint the example, start with the tree trunks, each leaf mass made with one rolling movement of the brush. Then add the earth lines.

For the storm cloud, load a white-haired brush with water then an indigo wash, tip the brush in burnt sienna and use a rolling, looping motion of the brush to paint the cloud in one continuous stroke from right to left.

FIG. 1a With the brush held at an angle of 45° paint a large circular stroke, then without pausing or lifting the brush off the paper, paint a second circle as you move the brush to the left, slightly overlapping the first circle. Continue this motion to the end of the cloud.

Ten thousand pearls
 descend from the skies,
Washing away
 the lingering year,
Leaving the earth moist
 for the seeds of spring,
Heaven's gift for
 a prosperous season.

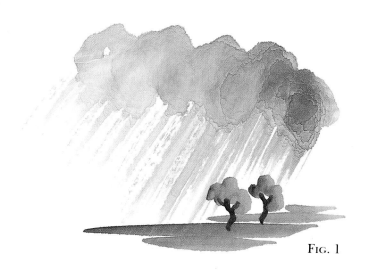

FIG. 1

FIG. 1a

Paint the falling rain by loading the brush with an indigo wash then pressing the hairs of the brush down on to the palette and twisting the brush to splay the hairs open. Paint downward from the cloud, dragging the hairs lightly over the rice paper, lifting the brush as it reaches the earth. Start on the right side and work across to the left.

SUMMER

FIG. 2 The poem clarifies the action of the painting. The birds have already departed, only the sound of their beating wings remains.

Paint the traveller, then the bamboo grove, then the rock lines.

WINTER

FIG. 3 The poem takes the visual images and expresses the symbolism behind each, thus going beyond the outward form to the heart.

Paint the bamboo first, then the pine tree, then the plum blossom, the branch before the blossoms.

FIG. 4 The poem continues past the images in the painting, into the world of the silent emptiness, beyond the horizon.

Paint the pine tree first, then the figure on the cliff edge, then the rock lines. Colour in all of this before adding the rolling waves of the mist, in the same techniques as used for the storm cloud in Fig. 1.

Fig. 2

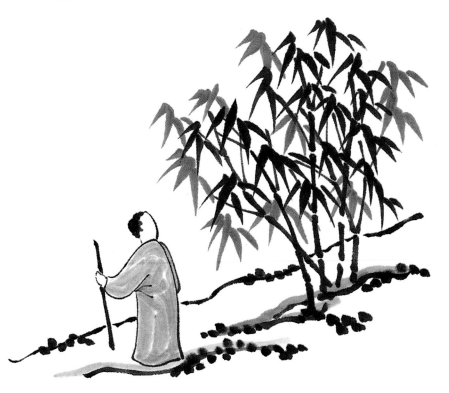

The old staff upon
 the ground
disturbs the birds
 in the bamboo.
Taking flight,
 they startle the traveller.

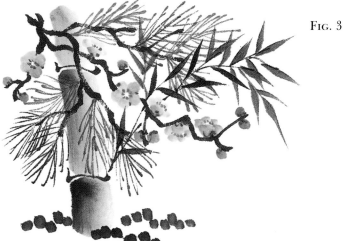

Fig. 3

Most of the trees are bare
 before the winter's gaze,
But the three friends
 still share their company
 with the traveller.
The gnarled pine portrays
 the vigour needed
 for a long life,
The resilient bamboo reminds
 us to be flexible
 before the winds,
The young plum
 blossoms with hope
 of spring's return.

The mist veils the distance,
 the open spaces are encircled;
Only an old pine tree
 on a mountain's edge
 remains to shelter
 the traveller;
Together they ride
 on the sea of clouds,
 like the ancient sage
 and his dragon.

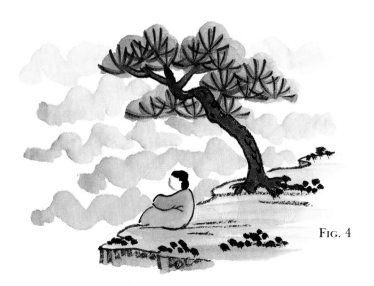

Fig. 4

Having journeyed far,
across valleys and along
rivers, climbed through forests
of fragrant pine and along
mist-shrouded ridges,
reaching the mountain peaks
to sit and contemplate the vast
expanses of earth and sky.
The mind takes flight and,
soaring above the world,
embraces the ancient truths
that remain beyond time.

PAINTED AND WRITTEN AT
BAMBOO MOUNTAIN STUDIO
SPRING 1989